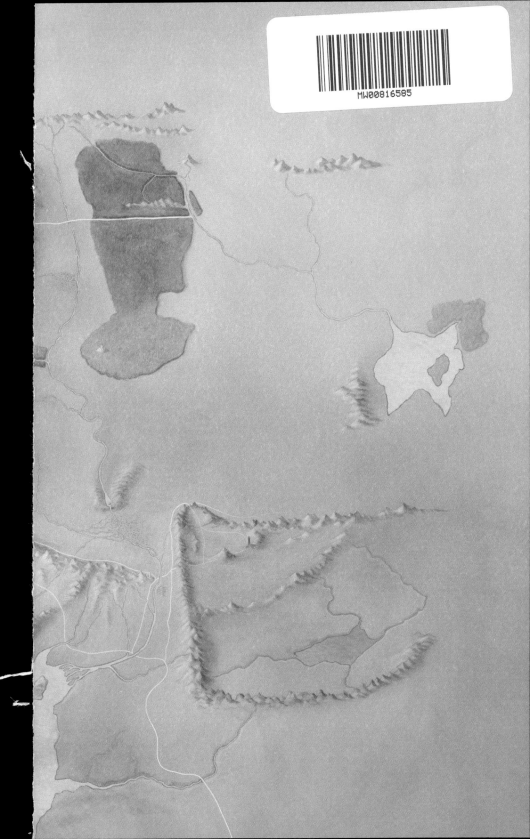

THE MAPS OF MIDDLE-EARTH

THE MAPS OF MIDDLE-EARTH

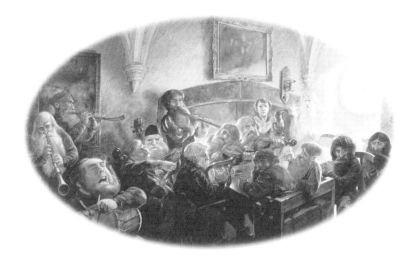

BRIAN SIBLEY

Illustrated by JOHN HOWE

WILLIAM MORROW
An Imprint of HarperCollins*Publishers*

HarperCollins*Publishers*
195 Broadway
New York, NY 10007

www.harpercollins.co.uk

HarperCollins*Publishers*
Macken House, 39/40 Mayor Street Upper,
Dublin 1 D01 C9W8, Ireland

www.tolkien.co.uk
www.tolkienestate.com

Published by HarperCollins*Publishers* 2024
1

This omnibus edition first published in Great Britain by HarperCollins*Publishers* 2003,
and its content first published separately by HarperCollins*Publishers* under the titles
THE ROAD GOES EVER ON AND ON: The Map of Tolkien's Middle-earth in
1994, 2009, THERE AND BACK AGAIN: The Map of *The Hobbit* in 1995, 2010 &
THE MAP OF TOLKIEN'S BELERIAND and the Lands to the North in 1999, 2010

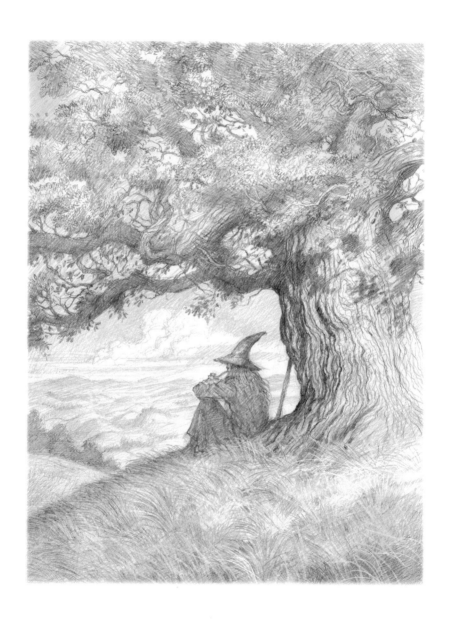

CONTENTS

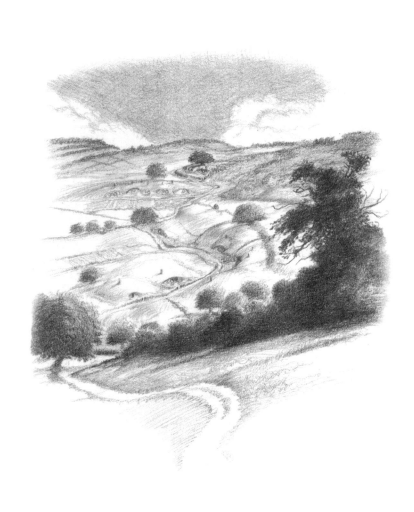

PREFACE

Every literary map is the pictorial story of a journey and, in the case of the stories of J. R. R. Tolkien, every map itself represents a journey of invention and discovery. As for this volume, it is the outcome of a thirty-year journey, beginning in 1994 when John Howe and I were commissioned to create a publication featuring a colour, fold-out version of the map of Middle-earth which adorned *The Lord of the Rings*. The map, drawn by John, was accompanied by a gazetteer (written by me) of place-names and descriptions. *The Map of Tolkien's Middle-earth* was conceived in response to a trend for presenting fantasy maps in the style of 'real-world' paper-covered pocket-maps. The following year, we produced *There and Back Again: The Map of The Hobbit*, the cover of which featured John's now-iconic painting depicting the hallway at Bag End with its front door open onto the Road that goes ever on.

In 1999, John and I joined forces on a third collaboration, *The Map of Tolkien's Beleriand and the Lands to the North*. It was around this time that a young New Zealand filmmaker

named Peter Jackson compiled a short film in support of an ambitious movie project he was pitching to Hollywood: nothing less than a live-action film of *The Lord of the Rings*. Included – as an indication of Tolkien's popularity – was a shot featuring books then in print about the author and his work, which prominently displayed the cover of our *There and Back Again* map. Then, when Jackson's epic eventually went into production, John was engaged (along with Alan Lee) as conceptual designer, and his view of Bag End's hallway inspired the physical film-set version of the Baggins's hobbit-hole.

In the year that Peter Jackson released the final episode of his trilogy, our three Tolkien maps were gathered into an omnibus edition, additionally containing a new map of the doomed island of Númenor, more fully described in the posthumously published *The Silmarillion* and *Unfinished Tales*, each edited by Christopher Tolkien from his father's manuscripts.

The 'map book saga' continued, a few years later, with three hardback 'Gift Editions', beginning in 2009 with the newly-titled *The Road Goes Ever On and On: The Map of Tolkien's Middle earth*, followed in 2010 by both the familiarly named *There and Back Again: The Map of The Hobbit* and a volume fulsomely re-titled as *West of the Mountains, East of the Sea: The Map of Tolkien's Beleriand*, the text of which underwent a few revisions. As for Númenor, it had – for that time – sunk without trace!

With this new edition, in addition to a number of textual revisions and many new illustrations by John, all these maps

(including that of Númenor) have been collected together once more. They have been arranged in the order in which they were drawn and written about rather than in the chronology of Tolkien's legendarium, to reflect the journey taken by John and myself in curating Tolkienian cartography.

Acknowledgements for this journey must, therefore, begin with my collaborator, John Howe, since his beautifully delineated maps and his elegant pencil art on the gazetteer pages represent the book's primary, *essential*, value.

Our mutual gratitude goes to Publisher, David Brawn, who commissioned the first of these books and to Tolkien Publishing Director, Chris Smith, who continued the process and has subsequently overseen the books' later metamorphoses. For this edition, thanks are due to Terence Caven (designer), Megan Donaghy (production manager), Millie Prestidge (editorial factotum and all-round invaluable support), Mary Thompson, Aisling Smith and Hany Sheikh Mohamed (the Foreign Rights team), and Mike Topping (cover designer). As ever, we are indebted to the Tolkien Estate for their continued support of all our endeavours.

'Acknowledgements' is, of course, an inadequate catch-all within which to list the names of J. R. R. Tolkien, the 'onlie begetter' of Middle-earth, and his dedicated and ever-diligent amanuensis, Christopher Tolkien, but without their rare talents there would have been absolutely no need for these maps!

<div align="right">

Brian Sibley, 2024

</div>

INTRODUCTION

About the Mapping of Middle-earth

Bilbo Baggins loved maps; in his hall at Bag End, we are told, there hung a large map of the Country Round, 'with all his favourite walks marked on it in red ink.' J.R.R. Tolkien also loved maps and they were to play an important part in the writing of his history of Middle-earth.

There is something fascinating about every map – perhaps it is the romance of place-names, or the mystery of symbols; maybe it is the sense of possessing a solution to the puzzle of *where things are*: the confidence of knowing *'You Are Here'* or *'How to Get There'* (or, as Bilbo would have said, 'There *and Back Again'*); possibly even the opportunity to take a bird's-eye view of some far-off corner of the world.

A map is a record of a very specific moment in time: the end-product of centuries of history, geography and language and every map plots the limits of the map-maker's knowledge. That is why, on the earliest maps those parts as

13

yet unexplored were left blank or marked with such cautions as 'Here there be dragons'. Of course, on *some* maps, such information might, indeed, have been accurate: after all, when Bilbo looked at Thror's Map he saw the dragon, Smaug, clearly marked in red, flying above the Lonely Mountain!

Ever since men have been making maps of the world around them, they have also been mapping the worlds of the imagination: from Eden to Hell, from Utopia to Never Land; from the islands discovered by Gulliver to Jim Hawkins' Treasure Island; from Narnia and Moominland to Discworld and Oz. No place, in fact, is too fantastical for the imaginative cartographer. An early example of J. R. R. Tolkien's fascination with cartography can be seen in a real rather than a fictional map, made in France during the First World War. A graduate in language studies from Oxford, Tolkien demonstrated his skills in map-making by charting enemy trenches in the Battle of the Somme with neatly penned roads, tracks, dug-outs and rows of small red crosses signifying barbed wire.

When trench-fever invalided Tolkien out of this war (in which two of his closest friends and so many of his generation were killed), he began work on an ambitious literary project – nothing less than the creation of a mythology that he intended to dedicate, simply 'to England'. Taking a blue pencil, Tolkien wrote on the cover of a very ordinary looking notebook, *The Book of Lost Tales*; and within its pages he began writing the first legend of what eventually became *The Silmarillion*.

Recalling the way in which the tales set in what he called 'Middle-earth' had developed, Tolkien said: 'Always I had the sense of recording what was already "there", somewhere: not of "inventing".' This process – crammed into what spare time he could find in a busy academic and family life – led Tolkien to 'record' one of his first fictional maps.

It was drawn on a sheet of examination paper from Leeds University (where Tolkien was reader in English Language from 1920–25), and in the top left-hand corner of the map are the printed words: 'Do not write on this margin'. Not that Tolkien the map-maker took much notice of such injunctions, as evidenced in 1937, when *The Hobbit* was published and the two maps in that book had left-hand margins that specifically contained writing – either in English or runes.

The drafting of this earliest vision of the landscape of Middle-earth – or what was then known as Beleriand – was made at a time when many of Tolkien's ideas for the 'Silmarillion' were still only sketchily outlined and many of its stories were yet to be fully developed.

In this First Age of Middle-earth, Men had yet to make their mark upon the landscape, and relatively few settlements are shown when compared with the maps that later accompany *The Lord of the Rings*. This was a time when Elves were more numerous than Men, yet only the cities of Gondolin and Nargothrond, and the 'thousand caves' of Menegroth, intrude upon the natural wilderness of this early representation. One doomful location that was not depicted on the finished map is the dungeon stronghold, Angband, underground lair of Morgoth, the first Dark

Lord, atop which sat Thangorodrim, the Mountains of Tyranny. Despite the fact that they and their monstrous denizens would cast such a catastrophic shadow across all Beleriand, their precise location would remain nothing more than a dark rumour.

Christopher Tolkien (the author's son and assistant cartographer) recalled that although this was a working map 'not intended to endure', it remained in use for a number of years and became 'much handled and much altered'. In fact, this repeatedly amended map comprised numerous pages, glued together and stuck down onto backing sheets with various new sections pasted on top. It was, as Christopher put it, 'a strange, battered, fascinating, extremely complicated and highly characteristic document'. Indeed, lines of red, black and green ink became entangled with pencilled lines and blue-crayoned rivers while locations shifted or were re-named, roads were diverted and rivers redirected.

Although, with the passing years, Tolkien continued to work on the many tales that comprised 'The Silmarillion', he was ultimately defeated by time and, when he died in 1973, his work on this great and complex achievement remained incomplete. It was left to Christopher Tolkien to bring into publishable form those stories that his father had begun more than half a century earlier. It also fell to Christopher, in readiness for the publication of *The Silmarillion* in 1977, to prepare the book's cartography displaying Middle-earth in its earliest era: a world, begun as a sketch in ink and crayon by its creator fifty years before, being presented in

16

a form that would allow readers to journey with the heroes and villains of the First Age.

It had been in the late 1930s that Tolkien had found the vital clue to a full 'discovery' of Middle-earth while inventing the story that would become *The Hobbit*. In recounting to his children the adventures of Bilbo Baggins, he came to realise that 'the world into which Mr Baggins strayed' was, in fact, the very same Middle-earth of *The Silmarillion*, but in a much later age.

When *The Hobbit* was accepted for publication, Tolkien made two maps: one, a facsimile of Thror's Map of the Lonely Mountain; the other, a map of 'Wilderland', the lands beyond the Edge of the Wild: the Misty Mountains, the Great River, the Old Forest Road, Mirkwood, the Desolation of Smaug, and beyond (indicated only by an arrow) the Iron Hills. The Iron Hills would eventually be shown on other maps that Tolkien began charting when he embarked on writing a 'new *Hobbit*'. Also added later were the Sea of Rhûn, into which the River Running flowed; the Shire, where Bilbo and his adopted nephew, Frodo, had their home in Hobbiton; and all the country to the south of Wilderland. It would take twelve years for *The Hobbit* sequel to grow into *The Lord of the Rings* and it was, for Tolkien, a quest during which he was constantly making discoveries.

It transpired that not only was Bilbo's magic Ring a far more significant artefact than might have been supposed, but new characters kept entering the narrative and demanding to be written about. When Frodo arrived at Bree and encountered 'Strider', even Tolkien wasn't initially sure

where he had come from; and when, much later, Faramir crossed Frodo's path, Tolkien discovered not just a major new character for his story but, through him, much of the history of the people of Gondor.

'There are many maps in Elrond's house,' Gandalf told Pippin; and there were also many maps in Tolkien's house, to which he constantly referred whilst writing *The Lord of the Rings*, understanding, as he said: 'If you're going to have a complicated story, you must work to a map; otherwise you'll never make a map of it afterwards.'

The inspiration for many of the place-names on the maps of Middle-earth came from Tolkien's knowledge of philology and his fascination with the languages that he created; they were given an authenticity by distances being measured in leagues, furlongs, ells and fathoms; and they were coloured by the narrative descriptions given by characters. For example, when the Fellowship leave Lothlórien, Celeborn tells them: 'As you go down the water, you will find that the trees will fail, and you will come to a barren country. There the River flows in stony vales amid high moors, until after many leagues it comes to the tall island of the Tindrock, that we call Tol Brandir. . .'

What, perhaps more than anything, gives Middle-earth a quality which Tolkien identified as an 'inner consistency of reality', is its closeness to our own world. It is a place where the sun rises and sets as it does on earth and where the moon passes through phases; a place of mountain, forest, plain and fen, often wreathed in mist, fog and smoke, weathered by wind, rain and snow. Only the era and the presence of

magical beings and powers separates Middle-earth from our earth. 'I have,' said Tolkien, 'placed the action in a purely imaginary (though not impossible) period of antiquity.'

When it came to publishing *The Lord of the Rings*, Tolkien realised that the appearance of Middle-earth would be of great importance to his readers, but how was such information to be included in the book? 'Maps are worrying me,' Tolkien wrote to his publishers in April 1953, as the book underwent its final corrections for publication in three volumes. 'One at least (which would then have to be rather large) is absolutely essential. . .' Tolkien actually wanted to include *three* maps: one of the Shire, for the first and last volume; one of Gondor for the second and third; and 'a general small-scale map of the whole field of action' for all three books. These maps, he went on, were already in existence, 'though not in any form fit for reproduction. . .'

Nevertheless, Tolkien offered to 'try and draw them in

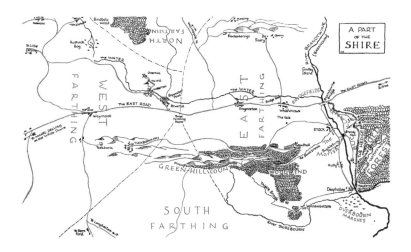

suitable form', and this he attempted to do using coloured inks and chalks. Six months later, however, he was still worrying: 'The Maps. I am stumped,' he told his publishers. 'Indeed in a panic. They are essential; and urgent; but I just cannot get them done. I have spent an enormous amount of time on them without profitable result. Lack of skill combined with being harried. Also, the shape and proportions of "The Shire" as described in the tale cannot (by me) be made to fit into shape of a page; nor at that size be contrived to be informative. . . I feel that the maps ought to be done properly. . . Even at a little cost there should be picturesque maps, providing more than a mere index to what is said in the text. I could do maps suitable to the text. It is the attempt to cut them down and omitting all their colour (verbal and otherwise) to reduce them to black and white bareness, on a scale so small that hardly any names can appear, that has stumped me.'

As he would later do with *The Silmarillion*, Christopher Tolkien prepared the final cartography for inclusion in *The Lord of the Rings* when the book was published in 1954 (Parts One and Two) and 1955 (Part Three). These maps, like the one hanging in Bag End, had strong lines, red-inked names, and pictorial representations of mountains, hills, trees, fens and citadels, and became the first published visualisation of Middle-earth in the Third Age.

Gazing at the peaks of the Misty Mountains, Gimli the Dwarf says: 'I need no map. . . Only once before have I seen them from afar in waking life, but I know them and their names. . .' For the rest of us, these maps – as re-drawn in

this volume with John Howe's evocative decorations – may serve as a reminder of names and places; and enable us, with the help of the accompanying key, to locate some of the major events referred to in J. R. R. Tolkien's books. But whether we study them closely or hang them on the wall, these maps (like those on which they are based) are a way into – or, perhaps, *back* into – the enduringly fascinating realm of Middle-earth.

Brian Sibley

Reinterpreting perhaps the most iconic map in fantasy literature is no small undertaking, and inevitably a challenge. I peered endlessly at J.R.R. Tolkien's map, interrogating every stroke and line of the pen to try and guess what might have been going through his mind as he made them. The visual language of Tolkien's map is simple yet astonishingly evocative, something I tried to respect totally. Seeking the balance between decoration and geography guided the approach, tying myself in knots (quite literally) to create a sober but detailed border, with narrow illustrations designed to frame, but not detract from, the map itself.

I re-read the books and filled the margins with notes on place-names and geographical features, wishing they could be included in the map. Perhaps one day... Despite this, I must have been so concentrated on painting the geography that I made a truly embarrassing number of errors in the place-names, and thus spent a penitent afternoon in London correcting them.

John Howe

THE ROAD GOES EVER ON AND ON:

About the Map of Middle-earth

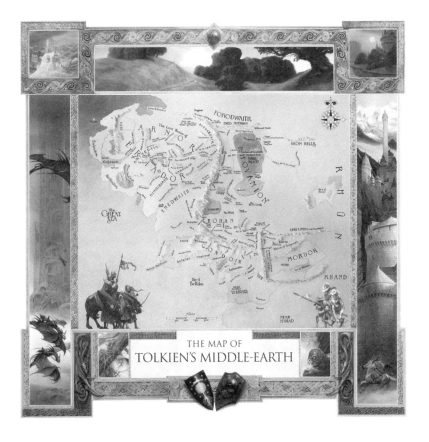

THE MAP OF
TOLKIEN'S MIDDLE-EARTH

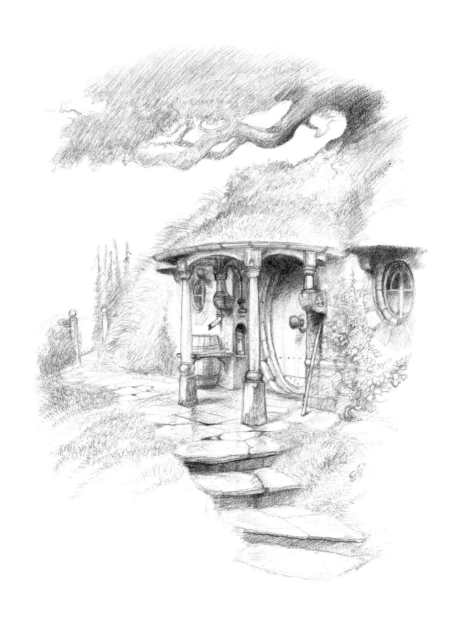

If you are setting out on a journey (especially if you are planning on having any adventures) the one thing you need is a map. The map of Middle-earth shows many of the places described in J. R. R. Tolkien's books *The Hobbit, or There and Back Again* and *The Lord of the Rings*.

Middle-earth, as it is depicted in these stories, is an amazing, beautiful and mysterious place; but it is also, sometimes, ugly, terrible and dangerous. There are towering, snow-capped mountains, beneath which run deep, dark, underground passageways. There are tangled, airless forests, where strange creatures lurk in the half-light; and there are woods where the grass beneath the trees is sweet-smelling and studded with small golden flowers, shaped like stars. There are high-towered citadels; black, iron-gated strongholds; towns built upon lakes, in trees and under hills; and, away in the east, a land of smoke, fire and sinister shadows.

However, it was in a quiet green corner of Middle-earth called the Shire (to be found in the top left-hand corner of this map), that Bilbo and Frodo Baggins's adventures really began. The Shire was a rural country with gently rolling hills,

woods, hedgerows, farms and fields and a meandering river, simply called The Water, which had given its name to sleepy little villages with inns and water-mills such as Bywater and Hobbiton-across-the-Water.

Just above Hobbiton stood the Hill, into the side of which was built Bag End, the homely hobbit-hole of Mr Bilbo Baggins. This curious, but comfortable, house had a round door, painted green, with a shiny brass knob in the exact middle. Inside was a long tunnel leading to the different rooms, the best of which had deep-set, round windows that looked out over the garden to the meadows beyond.

Bilbo, like most of the small, furry-footed hobbits who lived in the Shire, wasn't in the least interested in adventures, which he described as 'nasty, disturbing uncomfortable things' that make you late for dinner! Then, one day, along came Gandalf the wizard with thirteen Dwarves and a *map* which showed places Bilbo had never seen or even heard of before: far-off places beyond the Edge of the Wild, like the Lonely Mountain (marked at the top of this map with its proper name, 'Erebor'), now the home of the dragon, Smaug, thief and guardian of a great hoard of treasure that had once belonged to the Dwarves.

The only dragon anywhere near Bag End was 'The Green Dragon' inn at Bywater; and although nervous at the prospect of meeting a real dragon, Bilbo impetuously agreed to leave his home and help the Dwarves recover their treasure. It was a long way to the Lonely Mountain and a lot of exciting – and sometimes terrifying – things happened to them long before they ever got there. Most importantly, as

it later turned out, Bilbo encountered the creature, Gollum, and 'acquired' a ring with magical powers. . .

More than seventy years later, Bilbo's cousin and nephew, Frodo, was living in Hobbiton, when Gandalf once more arrived at Bag End. This time he had no Dwarves with him and no map, but he brought sinister news. The ring which Bilbo had found was much more than just a magic ring, it was a ring of great power.

Sauron the Dark Lord had forged it, many years before, in the fires of Mount Doom in the land of Mordor. The ring was made to control other rings given to the free peoples of Middle-earth, but it had long been hidden from the fiery gaze of Sauron's eye. Now, however, he knew that the One Ring was no longer lost, and he was seeking to find and use it once more. Without knowing what lay ahead, Frodo agreed to take the Ring out of the Shire; and accompanied

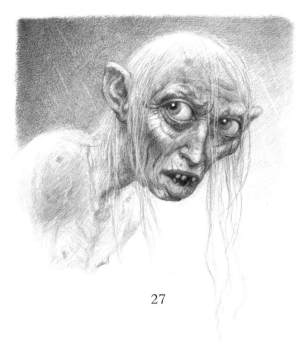

27

by his two cousins, Merry Brandybuck and Pippin Took, and his gardener, Sam Gamgee, he set out upon the same road that his uncle had taken at the start of *his* adventure. . .

Danger soon pursued them on the open road in the shape of Ringwraiths, nine black servants of the Dark Lord, riding first on horses, then on great flying beasts with leathery wings. But they met with other, unexpected, dangers: in the Old

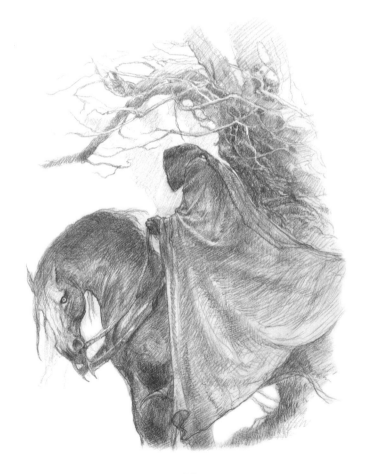

Forest, on the bank of a cool river, a strange sleepiness crept over the travellers, and they found themselves caught and trapped in the cracked bark and tangled roots of an ancient tree, called Old Man Willow. And, on the Barrow-downs, they encountered a ghostly Barrow-wight, lurking in an old burial mound among hills where standing stones loomed up like jagged teeth out of a sea of fog.

Any journey through Middle-earth was affected not just by weather – wind, rain and mist, blizzards and thunderstorms, and great extremes of heat and cold – but also by the terrain of the landscape, which presented its own obstacles and dangers: marsh, mire and mud; river, lake and rapid; and vast, unscalable mountain ranges.

One of these, the Misty Mountains, had presented an impassable barrier to Bilbo and the Dwarves. Later, this great rocky backbone of Middle-earth proved similarly hazardous for Frodo and his companions. Snow on the high passes drove them back and forced them to take a darker route underground, through the twisting, turning tunnels of Moria, the old abandoned mines of the Dwarven kingdom deep beneath the mountains.

Such subterranean routes required great courage of those who took them, whether through the maze-like Mines of Moria to the fateful Bridge of Khazad-dûm; through the stinking, cob-webbed passageways that formed the lair of the monstrous spider, Shelob; or the ghost-inhabited Paths of the Dead that ran beneath the Haunted Mountain. And across every road in Middle-earth fell the fearful shadow of far-off Mount Doom.

Over hill and under ground ran their way, across wide, open plains and along shady pathways through woods and forests that were to play as important a part in the adventures of Frodo as they had in those of Bilbo. In the beautiful woodland kingdom of Lothlórien, Frodo and his companions found a timeless land of cool breezes and sweet scents, where Elves lived on platforms, or flets, in the branches of tall mallorn trees heavy with golden blossoms. And, in the heart of Lothlórien, they visited Caras Galadhon, the City of Trees, where, under a shadowy cloud of leaves, high among the huge limbs of one of the mightiest trees in Middle-earth, they met Lord Celeborn and the Lady Galadriel.

It was not Frodo, but Merry and Pippin who found themselves in a very different woodland: a place where the trees gleamed with soft greens, rich browns and smooth black-greys. This was Fangorn, a huge, shaggy forest of lichen-hung trees where the young hobbits met Treebeard the Ent, a towering, troll-like figure, fourteen feet high, with skin like grey-green bark and a bushy beard of twig and moss. Treebeard spoke of his land as a place 'Where the roots are long. And the years lie thicker than the leaves...'

Both Lothlórien and Fangorn were safe havens from the terrors of Sauron's dark powers, as were Rivendell, and the House of Tom Bombadil on the edge of the Old Forest. Here the weary hobbits feasted on white bread and butter, cream and honeycomb, cheese and ripe berries in a long, low room filled with candles and hanging lamps, and wide lily-bowls amongst which sat Tom's wife, Goldberry, the River King's daughter.

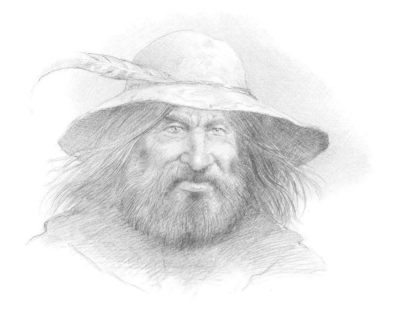

Tom Bombadil was master of wood, water and hill, and no evil could approach his house; other places, with no such protection, required a different form of defence. Many, like Edoras, used the geographical features of the landscape. The Golden Hall of King Théoden, Lord of the Horsemen of Rohan, stood upon a solitary foothill of the White Mountains and was ringed with a deep dike and a mighty wall topped by a thorny fence. And, to the north-west of Edoras, stood the fortified gorge of Helm's Deep. With its twenty-foot-high stone wall and its lofty tower, the Hornburg, it had been built upon a great spur of rock, jutting out from the surrounding cliffs. Despite being attacked by a swarming army of Saruman's Uruk-hai, Helm's Deep was held and great deeds of heroism were done in the battle.

To the south stood Minas Tirith, the white-walled, many-towered citadel of Gondor. Built upon a hill joined to Mount Mindolluin, Minas Tirith was ringed by seven strong walls, the topmost of which ran out onto a great stone outcrop, its sharp edge rising in a high sweeping curve seven hundred feet above the city gates. Besieged by Sauron's forces with catapults, siege-towers and battering-rams, the Great Gates were broken down, but Minas Tirith did not fall and the armies of the west, though heavily outnumbered, fought the Battle of the Pelennor Fields and were victorious.

In stark contrast to these halls and cities of the free people, were the great bastions of darkness: Orthanc, Saruman's stronghold at Isengard, a gleaming black tooth of rock, ringed with stone and built against the last peak of the Misty Mountains; and the Barad-dûr, the immeasurably strong fortress of the Dark Lord, Sauron, with battlement upon battlement of black stone and a steel gate by which none who went in, ever came out.

These then are some of the many extraordinary places to which Bilbo and Frodo travelled during their journeys through Middle-earth. When Frodo and his companions had first set out from the Shire on their great adventure, he had quoted a song made up by Bilbo, many years before:

> *The Road goes ever on and on*
> *Down from the door where it began.*
> *Now far ahead the Road has gone,*
> *And I must follow if I can,*
> *Pursuing it with eager feet,*

Until it joins some larger way
Where many paths and errands meet.
And whither then? I cannot say. . .

Using this map, and the accompanying key, you can also follow that road and visit, in your imagination, the mountains, rivers, lakes and forests of J. R. R. Tolkien's Middle-earth.

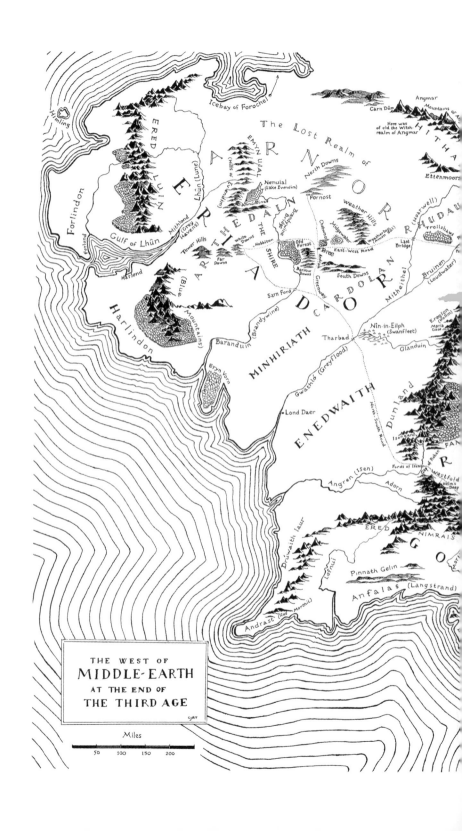

THE WEST OF
MIDDLE-EARTH
AT THE END OF
THE THIRD AGE

Miles

50 100 150 200

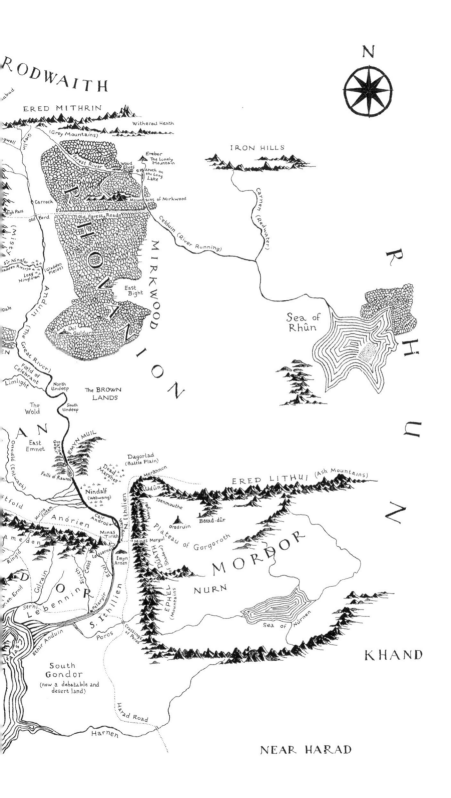

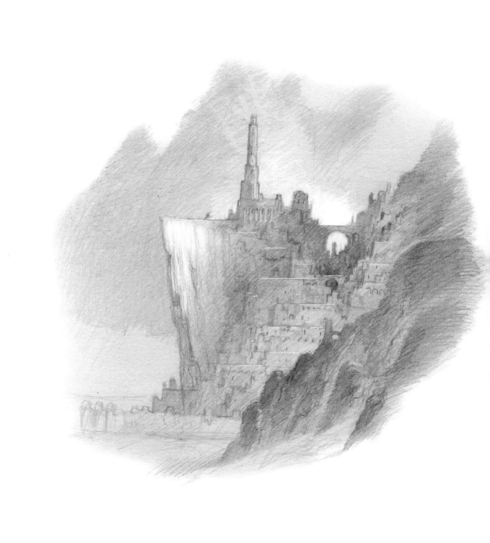

PLACES ON THE MAP OF
MIDDLE-EARTH

AMON SÛL, see WEATHERTOP

ANDUIN, the Great River, in which the One Ring (cut from Sauron's hand) slipped from the finger of Aragorn's ancestor, Isildur, and was lost. Long afterwards, it was found by a hobbit-like creature named Déagol who was murdered by his friend, Sméagol, in order to take the ring. Sméagol later lived under the MISTY MOUNTAINS and became known as Gollum. When the Fellowship of the Ring went south by boat from LOTHLÓRIEN, they travelled down this river, pursued (on a log) by Gollum.

ANGMAR, the Witch-realm of the north, once ruled by the Lord of the Nazgûl, chief servant of the Dark Lord Sauron.

BARAD-DÛR, the Dark Tower, Sauron's fortress in the land of MORDOR and, at the time of the War of the Ring, the greatest in all Middle-earth. Atop the Dark Tower was an eye 'that did not sleep' and its foundations would endure as long as the One Ring was not destroyed.

BARROW-DOWNS, where, trapped by fog, Frodo, Merry, Pippin and Sam were lured between two tall standing stones into the burial chambers of a dreadful Barrow-wight, an encounter from which they were rescued by Tom Bombadil.

BREE, where Frodo and his companions stopped at 'The Prancing Pony' inn. Frodo accidentally used the Ring and disappeared; the landlord, Barliman Butterbur, gave Frodo a belated message from Gandalf; and the four hobbits met Aragorn then in his guise as a Ranger named 'Strider'.

BRUINEN, the river Loudwater, which was crossed by the EAST-WEST ROAD at the FORD OF BRUINEN, the upper reaches of which were controlled by Elrond of RIVENDELL who could cause them to flood if peril threatened the Last Homely House.

BUCKLAND, where Frodo lived as a young hobbit. It was to a home near here (in Crickhollow) that he pretended to be moving when he set off on his journey. It was on the road to Buckland that Frodo and his companions first realised that they were being followed by Black Riders; and it was in the nearby Woody End that they met Gildor and the Elves. While taking a short cut to avoid the pursuing Riders, they trespassed onto the land of Farmer Maggot, who gave the hobbits hospitality including a memorable meal of home-grown mushrooms.

CAIR ANDROS, island in the ANDUIN, north of MINAS TIRITH that was, for a time during the War of the Ring,

captured by a force from the MORANNON. Its name means 'ship long-foam' referring to its high prow, against which the river broke with much foaming of its waters.

CARROCK, near this rock in the River ANDUIN was Beorn's House, home of the shape-shifting bee-keeper who, in *The Hobbit*, gave hospitality to Gandalf, Bilbo and the Dwarves in his great wooden hall.

CELEBRANT (Silverlode), river flowing through LÓRIEN, which the Fellowship take on leaving the city of the Galadhrim on their journey to the ANDUIN.

CHETWOOD, the wooded valley beneath BREE-hill, through which Strider leads the hobbits in order to avoid the possibility of pursuit by Black Riders on the EAST-WEST ROAD.

DAGORLAD (Battle Plain), site of the conflict between the forces of Sauron and the armies of the Last Alliance of Elves and Men at the end of the Second Age of Middle-earth, in which the Dark Lord was overthrown while Gil-galad and Elendil were slain.

DEAD MARSHES, fenland to the west of the ancient site of the Battle of DAGORLAD. Gollum led Frodo and Sam through these treacherous marshes where the dead of that battle lay buried, their corpse candles giving off an eerie light.

DIMRILL DALE, the valley which the Fellowship came into after leaving the Mines of Moria. From its lake,

Mirrormere (Kheled-zâram), the river CELEBRANT (Silverlode) flowed down to LÓRIEN.

DOL AMROTH, the coastal citadel from where the Prince Imrahil rode to the aid of GONDOR.

DOL GULDUR, former fortress of Sauron on the southern edge of MIRKWOOD. The Dark Lord was driven out of this tower by the White Council and fled to MORDOR. However, the fortress remained a stronghold for Sauron's forces during the War of the Ring until it was finally destroyed by the Elves of LÓRIEN, led by the Lady Galadriel.

EAST-WEST ROAD, the Great East Road running from BREE to the FORD OF BRUINEN.

EDORAS, city of ROHAN where, in Meduseld the Golden Hall, Gandalf first sought the aid of Théoden, King of the Mark, and was given leave to take a horse for his use, choosing (or being chosen by) Shadowfax. Later, Gandalf returned to confront the king with news of the rise of Sauron and the treachery of both Saruman and Théoden's own counsellor Gríma, known as Wormtongue. In the hills south-west of Edoras was the Hold of Dunharrow, the refuge to which the women and children of the Mark were sent for safety, under the protection of Théoden's niece, Éowyn; and from where Aragorn took the Paths of the Dead under Dwimorberg, the Haunted Mountain.

EMYN MUIL, the rocky region surrounding Nen Hithoel, the lake above the FALLS OF RAUROS. After the breaking of the Fellowship, Frodo and Sam passed across the eastern side to the DEAD MARSHES and began their journey towards MORDOR.

EPHEL DÚATH, the Mountains of Shadow, a mountain range protecting the western and southern borders of MORDOR.

EREBOR, the Lonely Mountain, former stronghold of the Dwarf lord, Thráin, King under the Mountain. It was here, in *The Hobbit*, that Bilbo had his conversation with Smaug the dragon; and it was at the Front Gate that the

Battle of the Five Armies was fought in which Elves, Men and Dwarves (aided by Beorn, the Great Eagles of the north and one hobbit) battled with goblins and Wargs.

ERECH, the hill where Aragorn gathered with the Oathbreakers, the Army of the Dead, before attacking the enemy fleet at PELARGIR.

ERED LITHUI or the Ash Mountains, a mountainous range on the northern border of MORDOR separating it from RHOVANION.

ERED NIMRAIS, the White Horn Mountains, a range of snow-covered peaks running westward from MINAS TIRITH, which sheltered the refuges of Dunharrow and HELM'S DEEP and beneath which ran the Paths of the Dead. Rising above MINAS TIRITH was the great peak of Mount Mindolluin. To the north, below the purple shadows of the mountain, was Drúadan Forest, home of the Woses, an ancient, wild, woodland people who aided the allies in breaking the Siege of GONDOR.

ESGAROTH, Lake-town, built on the Long Lake. In *The Hobbit*, Bilbo and the Dwarves visited the town, following their escape from the hall of the Elvenking. Smaug the dragon later attacked and destroyed Esgaroth, but was slain by Bard the Bowman.

FALLS OF RAUROS, waterfall at the southern end of the lake, Nen Hithoel. On the south-western bank was Amon Hen (the Hill of the Eye) where Frodo sat on the Seat

of Seeing and saw far across Middle-earth to the Dark Tower of Sauron. It was nearby, at Parth Galen, that the Fellowship was broken when Orcs captured Merry and Pippin and killed Boromir. Frodo and Sam crossed Nen Hithoel by boat and entered the eastern EMYN MUIL.

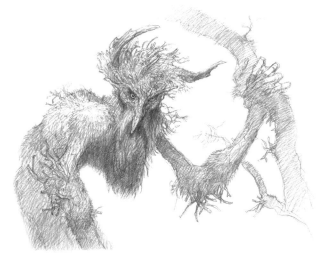

FANGORN, the ancient forest where Merry and Pippin (having escaped from Orcs) encountered Treebeard and his fellow Ents, tree-herds who had grown like the trees for which they were responsible. Treebeard, having summoned an Entmoot, led an army of Ents and Huorns against Saruman's fortress at ISENGARD. It was here also, on Treebeard's Hill, that Aragorn, Gimli and Legolas were reunited with Gandalf – now Gandalf the White.

FAR HARAD, southern realm with Near Harad, populated by the warlike tribes of the Haradrim who joined with Sauron's forces in the War of the Ring fighting from

war-towers mounted on large elephantine creatures called Oliphaunts, or *mûmakil*.

FIELD OF CELEBRANT, site of ancient battle between the men of the West and Easterlings owing allegiance to Sauron.

FORD (OF BRUINEN), where, following Bilbo and the Dwarves' escapade with the trolls in *The Hobbit*, the travellers crossed the river (named in *The Lord of the Rings* as the Bruinen, or Loudwater) and so came to 'the very edge of the Wild'. It was from here that Gandalf led them along a path marked by white stones to Imladris, the House of Elrond. Years later, it was to this crossing that Frodo was pursued by the nine Black Riders on his desperate flight to the safety of RIVENDELL.

FORDS OF ISEN, site of terrible battles between the Rohirrim and the forces of Saruman. Here, Gandalf supervised the burial of the warriors of the Mark who were slain, and mustered the survivors.

GONDOR, the Southern Kingdom of Middle-earth, founded in the Second Age by the Dúnedain, the Men of Númenor. Its capital city during the War of the Ring was MINAS TIRITH.

GREY HAVENS, the harbour on the firth of Lune from which the Ring-bearers (Frodo, Bilbo, Gandalf, Elrond and Galadriel) set sail on their final journey, across the Sundering Seas into the Undying Lands.

HELM'S DEEP, a defended refuge in a gorge cut by the Deeping-stream. Named after Helm Hammerhand, former king of ROHAN. The fortification, the Hornburg, was later the site of the Battle of Helm's Deep in which Aragorn, Legolas, Gimli and King Théoden's nephew, Éomer, drove back the Uruk-hai hordes.

HIGH PASS, the way over the MISTY MOUNTAINS east of RIVENDELL; it was here that Thorin and company were captured by goblins in *The Hobbit*.

HOBBITON-ACROSS-THE-WATER, a hobbit village in THE SHIRE. On The Hill was Bag End, Bilbo and Frodo Baggins's hobbit-hole, with its round doors and windows, from where both set out on their adventures. At the bottom of The Hill ran a river, called The Water, and nearby was the village of Bywater, site of the last battle fought in the War of the Ring.

IRON HILLS, once the home of Dáin the Dwarf who, in *The Hobbit*, fought in the Battle of the Five Armies.

ISEN, River, see FORDS OF ISEN

ISENGARD, a great ring of rocks surrounding the black stone tower of Orthanc, citadel of Saruman the White, later Saruman of Many Colours. When Saruman became an ally of Sauron, he imprisoned here his brother wizard, Gandalf. Later the great eagle, Gwaihir the Windlord, rescued Gandalf from Orthanc's highest pinnacle and carried him to EDORAS. The grim stronghold was finally destroyed by the Ents of FANGORN.

ISENMOUTHE, fortified pass in MORDOR, where Frodo and Sam managed to escape from the Orc army taking them to Udûn, the steep-sided valley in the north-west.

ITHILIEN, the fair country between the ANDUIN and the Mountains of MORDOR. It was here that Frodo and Sam met Faramir, brother of Boromir, who took them to a refuge behind the waterfall at Henneth Annûn, the 'Window of the Sunset'.

KHAND, realm to the south-east of MORDOR, inhabited by the Variags, a Mannish race allied with Sauron.

LONELY MOUNTAIN, see EREBOR

LÓRIEN (LOTHLÓRIEN), the wooded realm of the Elven-folk, where the tallest and most beautiful trees in Middle-earth grew; trees with silver bark and golden leaves. It was to Caras Galadhon, the Elven-city among these trees, that the Fellowship were led blindfold by Haldir the Elf. Here they were greeted by the Lord Celeborn and the Lady Galadriel, in whose Mirror (a stone basin filled with water) Frodo and Sam saw visions of things happening far beyond the golden woods of Lothlórien.

MIDGEWATER, a boggy tract of land north of the EAST-WEST ROAD, through which Strider led Frodo and the hobbits on the way to WEATHERTOP. A mass of shifting quagmires, the Midgewater Marshes were infested with tiny flying insects. 'Midgewater!' said Pippin, 'There are more midges than water!'

MINAS MORGUL, once Minas Ithil (the Tower of the Rising Moon), the location of one of the *palantíri* (seeing-stones), later used by Sauron. It was from the nearby Morgul-road that Gollum led Frodo and Sam up and into the cobwebbed lair of Shelob, the great spider. The passage guarded by Shelob led to Cirith Ungol, a tower originally built by GONDOR to keep watch on MORDOR. It was here that Frodo, after being stung by Shelob, was imprisoned by Orcs and rescued by Sam.

MINAS TIRITH, the Tower of Guard; formerly Minas Anor (the Tower of the Setting Sun), principal city of GONDOR. Within its seven circular walls stood the Citadel, with the King's House and the White Tower of Ecthelion. Here, Denethor, last Steward of Gondor and father of Boromir and Faramir, consulted the *palantír* ('seeing-stone') and, falling under the mind of Sauron, grew mad and believed the city would be taken by the Dark Lord.

But, although besieged, Minas Tirith did not fall. At the Battle of the Pelennor Fields, during which King Théoden was slain, the allies faced and drove back the hosts of MORDOR. Éowyn (disguised as a man), killed the steed of the Lord of the Nazgûl but was badly wounded and was only saved from death by the heroism of Merry. The wounded were cared for in the Houses of Healing, but Denethor, taking the unconscious body of his son, Faramir, lit a funeral pyre. Although Gandalf rescued Faramir, Denethor died in the flames.

It was in Minas Tirith, following the fall of MORDOR,

that Aragorn was crowned King Elessar and married to the Lady Arwen, daughter of Elrond of RIVENDELL.

MIRKWOOD, a gloomy forest of old trees, strangled with ivy. It was here, in *The Hobbit*, that the Dwarves were attacked by giant spiders and bound up with cobwebs. They were rescued by Bilbo using the Ring to make himself invisible. At its south-western edge stood DOL GULDUR.

MISTY MOUNTAINS, beneath which, in the north, lay the Goblin Town visited by Bilbo in *The Hobbit*. It was in the passageways under this town that Bilbo met Gollum and found the One Ring. On the eastern side of these mountains was the Eagle's Eyrie, to which the Lord of the Eagles carried Bilbo and his companions after they had been attacked by Wargs.

In the southern arm of this range rose three great peaks: Caradhras (Redhorn), Celebdil (Silvertine, also known as Zirakzigil) and Fanuidhol (Cloudy Head). The Fellowship of the Ring planned to cross the mountains by the Redhorn Pass but were prevented by storm and snow. Entering MORIA GATE, they made their way through the old Dwarf kingdom of Khazad-dûm, emerging by the Great Gates into DIMRILL DALE. It was on the highest peak of Celebdil that the final struggle took place between Gandalf and Durin's Bane, the Balrog.

MORANNON, the Black Gate, built by the men of GONDOR to keep watch on MORDOR at the beginning of the Third Age, following the defeat of Sauron. Two vast iron doors shut fast beneath a frowning arch, the gate closed off Cirith Gorgor, the Haunted Pass. Guarded by twin defences – Carchost (Fang Fort) and Narchost (Fire-tooth), sometimes named the Teeth of MORDOR – it was in front of this gate that Gandalf had parley with the Mouth of Sauron and Aragorn gathered his army for the Battle of the Morannon.

MORDOR, the black land of terror, named from the desolation caused by its being possessed by the Dark Lord Sauron. Within its mountain walls (the ERED LITHUI and EPHEL DÚATH) was the Plateau of Gorgoroth, a landscape comprising hills of slag, broken rock and blasted earth and dominated by ORODRUIN (Mount Doom), the volcanic mountain in the fires of which Sauron had forged the One Ring, and BARAD-DÛR, the Dark Tower, Sauron's mighty fortress first erected and eventually destroyed during the Second Age of Middle-earth and later rebuilt towards the end of the Third Age. In the southeast area of the region was the SEA of NÚRNEN, a large inland body of water that rendered the surrounding area of Nurn fertile land to be farmed by Sauron's slaves.

MORIA GATE, the Doors of Durin, inscribed with the words 'Speak, friend, and enter', which only opened to the Fellowship when Gandalf spoke the password – 'mellon', the Elvish word for 'friend'. In front of these doors lay a

dark pool, within which lurked the Watcher in the Water, a ghastly, tentacled creature.

MOUNT DOOM, see ORODRUIN

MOUNTAINS OF MIRKWOOD, near here, on the Forest River, stood the Elvenking's Halls, where, in *The Hobbit*, the Dwarves were held captive until Bilbo rescued them and helped them escape, by barrel, to ESGAROTH.

NIMRODEL, stream flowing from the MISTY MOUNTAINS to join with the river CELEBRANT. The Fellowship rested by its banks and Legolas remembered that it was the subject of many old Elven songs recalling 'the rainbow on its falls, and the golden flowers that floated in its foam.'

NURN, farmland, worked by slaves to provide food for Sauron's armies. After the fall of MORDOR, King Elessar freed the slaves and gave them the land.

OLD FOREST, where Frodo and his friends fell afoul of Old Man Willow and were rescued by Tom Bombadil, who then, with his wife, Goldberry, entertained the hobbits in his house.

ORODRUIN (Mount Doom), the Mountain of Fire, a huge mass of ash and burned stone on the PLATEAU OF GORGOROTH in MORDOR. Here, in the Sammath Naur (Chambers of Fire) high inside the mountain, Sauron forged the One Ring. It was to the Crack of Doom, a rent in the floor of the Sammath Naur, that Frodo carried the Ring and where, after his final struggle with Gollum, it

was returned to the fires. With the end of the Ring came the fall of MORDOR, Frodo and Sam being rescued from the burning slopes of ORODRUIN by Gwaihir and the eagles.

OSGILIATH, Citadel of the Stars, city of GONDOR built during the Second Age of Middle-earth, through the midst of which flowed the River ANDUIN. Destroyed by GONDOR's enemies, it was rebuilt by Denethor, as an outpost to MINAS TIRITH. During the final days of the War of the Ring, Denethor sent his son, Faramir, to Osgiliath, an expedition that ended with Faramir being wounded.

PELARGIR, the port on the ANDUIN where Aragorn and the Shadow Host of the Dead seized the black-sailed fleet of the Corsairs of Umbar. Then, releasing the dead army to their rest, Aragorn took his men by ship to MINAS TIRITH.

PLATEAU OF GORGOROTH, the ruined wastelands of north-western MORDOR, pocked by Orc-pits; this desolate plain was dominated by ORODRUIN (Mount Doom) and the BARAD-DÛR.

RAUROS, see FALLS OF RAUROS

RHOVANION, also known as Wilderland, the Land Beyond or the Wild, an immense, densely wooded region of northern Middle-earth containing the forest Greenwood the Great and traversed by the River Anduin.

RIVENDELL, the Last Homely House east of the Sea, home of Elrond Halfelven. Rivendell was set deep within a fair valley of beech and oak trees, reached by long, steep, zig-zagging paths and finally approached across a narrow bridge. The air there was filled with the scent of flowers and trees, and the sounds of river, waterfall and Elvish songs. Twice visited by Bilbo on his journey 'there and back again', it was to Rivendell, some time after his adventures, that he eventually returned to live. And it was there that Frodo, his adopted heir, would come to attend the Council of Elrond at which the Fellowship of the Ring was established prior to his setting off on another, far longer and more dangerous journey.

ROHAN, the rolling grasslands that formed the kingdom of the horse-lords, ruled by King Théoden from his Golden Hall at EDORAS. It was on the plains of Rohan that Gandalf found, tamed and rode the horse, Shadowfax the Great.

SARN GEBIR, rapids on the River ANDUIN, where the Fellowship was attacked by Orc bowmen and Legolas slew one of the terrible flying creatures on which the Nazgûl rode.

SEA OF NÚRNEN, a large inland lake in the southeastern part of MORDOR; by making the region of NURN fertile land, it was farmed by the slaves of Sauron for feeding his armies. The lake was described as a 'dark sad water' or a bitter sea, suggesting both its colour and unpalatable taste.

THE SHIRE, a rural region of Eriador, populated by hobbits. The Shire was divided into four Farthings, its principal town being Michel Delving.

TROLLSHAWS, where, in *The Hobbit*, Bilbo and the Dwarves encountered the trolls who, with the coming dawn, were turned to stone. The stone trolls were later re-discovered by Frodo and his friends on their journey to Rivendell.

WEATHERTOP (Amon Sûl, 'the hill of the wind'), once the site of an ancient watchtower, where 'Strider' (Aragorn) and his hobbit-companions found a message scratched on a stone by Gandalf and where they were attacked by the Black Riders.

'Wilderland', the original map depicting Bilbo's journey 'there and back again' and rendered in pen and ink by J.R.R. Tolkien, is the most naïve and pictorial of his many maps, as well as being the least detailed and otherwise busy of them. It undeniably reflects, in evolving cartographic form, his first steps in the invention of the Third Age of Middle-earth. These qualities invited a grand illustrative freedom, so I carefully re-read 'An Unexpected Party' and matched each Dwarf to the instruments they play to create the scene surrounding a rather perplexed and decidedly put-upon putative burglar of dragon-gold... (I pursued this same exercise for the Hobbit trilogy, taking the design of the instruments far more thoroughly into Middle-earth, though in the end none actually made it to the screen.)

For the cover of the very first edition (reproduced as the dust-jacket of this book) the editor requested 'A scene looking out of Bilbo's front hall, please. Oh, and leave the door open. No Hobbits.' Informed by Tolkien's own drawing of the same view, grandly influenced by the Arts & Crafts movement and Norwegian stave churches, it turned out to be my first step of many into Bilbo's house, when Peter Jackson remarked 'It's a start, now can you turn about 180 degrees and draw the rest?'

John Howe

THERE AND BACK AGAIN:

About the Map of Wilderland

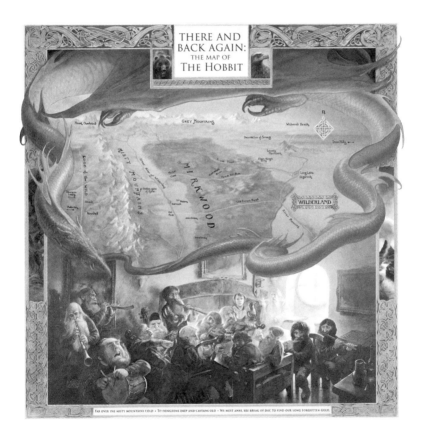

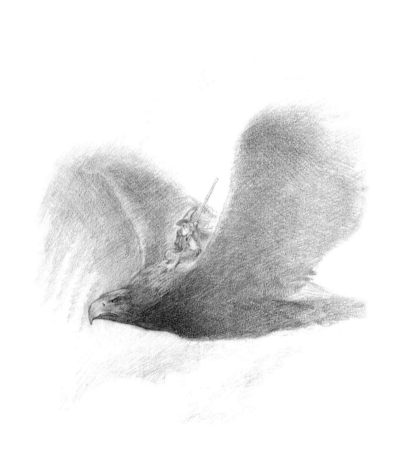

The title of J. R. R. Tolkien's book *The Hobbit* tells you exactly *who* it is about, and the subtitle – 'There and Back Again' – tells you, right from the beginning, that it is going to be the story of a journey. That journey turns out to be a long, thrilling and highly dangerous one, during which the hobbit in question, Mr Bilbo Baggins, encounters Dwarves, trolls, Elves, goblins, wild wolves, giant spiders and a fearsome fire-breathing dragon. All in all, the kind of exploit that ought never to have been undertaken without a map, which probably explains why, long before Tolkien had finished writing an account of Mr Baggins's journey, he was already drawing a map of it.

The story behind that map and that journey began to be written in the early 1930s when J. R. R. Tolkien, Professor of Anglo-Saxon at Oxford University, was marking examination papers. Suddenly, out of nowhere, some words came into his head. At the time, he didn't know what they meant, but he scrawled them down on a sheet of paper which one of the examination candidates had left blank. 'In a hole in the ground,' he wrote, 'there lived a hobbit. . .'

Although it was to be some while before Tolkien had time

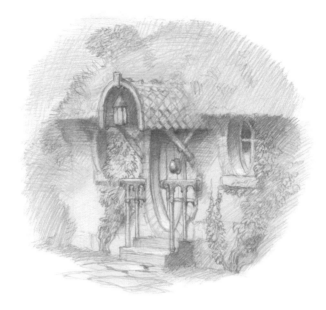

to think about who that hobbit was and what he was going to do with him, an adventure gradually began to unfold in his mind and was written down. In what was to become the book's first chapter, 'An Unexpected Party', the author introduced Mr Bilbo Baggins, a very well-to-do hobbit who lived at Bag-End, a comfortable hobbit-hole on The Hill, in the Shire.

Hobbits, said Tolkien, 'are (or were) a little people, about half our height', inclined to be fat in the stomach, with no beards (unlike Dwarves) but lots of curly brown hair that grew not only on their heads but on the tops of their feet as well, which meant that (since they also had leathery soles) they never wore shoes. Hobbits dressed in bright colours, had clever brown fingers, good-natured faces and 'deep

fruity laughs (especially after dinner, which they have twice a day when they can get it).'

Nothing would normally have induced Bilbo Baggins – or any other hobbit – to go in search of anything as disruptive as an adventure; but it soon became clear that an adventure had finally come in search of him, because through his round front door marched thirteen Dwarves and a wizard named Bladorthin.

It should be explained that Tolkien later decided to call the wizard 'Gandalf' – a name he had originally given to the chief Dwarf, whom he then named 'Thorin'!

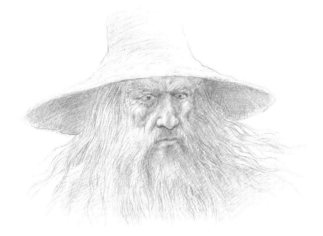

Gandalf, a curious old man with a long white beard, wore a tall pointed blue hat, a grey cloak and a silver scarf. Bilbo remembered him as a wandering wizard who used to visit the Shire, telling wonderful tales about dragons, goblins, giants and the like, and bringing remarkable fireworks and extraordinary gifts – such as 'a pair of magic diamond studs that

fastened themselves and never came undone till ordered'. What Bilbo (and probably Tolkien) had yet to discover was that Gandalf was a truly mighty magician.

As for the Dwarves, they turned out to be surprising guests. First to arrive was Dwalin who had a blue beard tucked into a golden belt; next was Balin, an old-looking Dwarf with a white beard; then came Kíli and Fíli with silver belts and yellow beards, followed by Dori, Nori, Ori, Óin and Glóin, Bifur, Bofur and Bombur who was 'immensely fat and heavy'. Last, but by no means least, was 'an enormously important dwarf', the great Thorin Oakenshield. Thorin's sky-blue hood with a silver tassel was soon hanging up in Bilbo's hall alongside two blue, two purple and two yellow hoods and others of dark-green, pale green, scarlet, grey, brown and white.

After the Dwarves had eaten Bilbo out of house and home, they entertained the hobbit with stories and songs about their ancient people who, long years ago, had worked as smiths. Deep underground, in hollow halls, hammers had rung on anvils as the Dwarves shaped and wrought their precious metals, carving goblets and harps of gold, forging swords with gem-encrusted hilts, making silver necklaces strung with flowering stars and crowns hung with dragon-fire.

Eventually, Bilbo discovered the real reason for this unexpected party. Thorin and his twelve companions were planning to set out on a long journey – across rivers and mountains, through woods and forests – to the Lonely Mountain, far away in the east, in the hope of getting back the treasures of their ancestors which had been stolen, and

were now being guarded, by the terrible dragon Smaug (or, as Tolkien first called him, Pryftan). Accompanying themselves on harp, flute and drum, the Dwarves sang of the journey they had to take:

> *Far over the misty mountains cold*
> *To dungeons deep and caverns old*
> *We must away, ere break of day,*
> *To claim our long-forgotten gold.*

As Bilbo listened to the Dwarf music, he felt himself being swept away into dark lands under strange moons; then, almost before he knew what was happening, the unadventurous Mr Baggins found that Gandalf had recommended him for the job of Burglar, and he was heading off on a quest for adventure.

Which is where the map came in. Drawn on parchment, it was given to Thorin Oakenshield (with an intricately shaped key) by Gandalf who explained that it had been made by the Dwarf's grandfather, Thrór. It showed the Lonely Mountain with Smaug (drawn in red) flying above it and another dragon wriggling its way across the paper towards 'The Desolation of Smaug', an area of tree-stumps, burnt and blackened by dragon's fire.

Thorin and his companions didn't know it at first, but the map was more than just a plan of the Mountain – it also told them how to use the key to get inside. No sooner had Tolkien written this map into his story, than he decided that he should make a drawing of it.

The Hobbit was never originally intended for publication; Tolkien wrote it as a serial to read to his three sons on winter evenings after tea. As he did so, he took Bilbo and the others through a land of wondrous places, peopled with outlandish creatures possessing magical powers. In fact, they had scarcely left the safety of Bilbo's village, Hobbiton-across-the-Water, before they fell headlong into the threatening company of a group of idiotic, but bloodthirsty, trolls. After

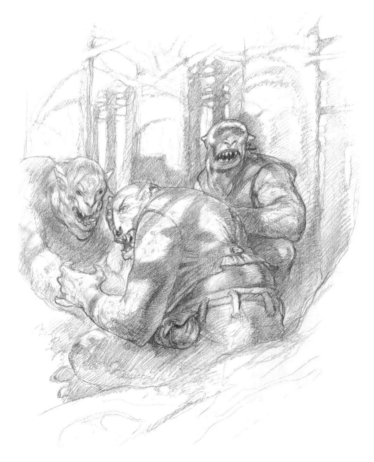

this hazardous beginning, Gandalf led Bilbo and the Dwarves by a perilous route, slithering and slipping down a zig-zag path, to the peaceful valley of Rivendell and then, across a narrow bridge over a tumbling river, to the Last Homely House. It was there, in Rivendell, on midsummer's eve, that Elrond, the master of that house, discovered a wonderful secret. Thror's map carried moon-letters – runes that could only be read when the map was held up to the white light of a moon of the same shape and season as that of the day on which they were written. Raising the ancient map to the moon's silver crescent, Elrond was able to read the runes and reveal their hidden message. . .

Eventually, the travellers left Rivendell and began their adventures in earnest, journeying over hill and under hill, through a world that seems as real as the one around us – but, of course, more magical. The geography of that world had its own excitements: there were high, windy mountain passes where lightning split the darkness and huge stone-giants hurled great rocks at one another; there was a tangled maze of airless passageways under the mountains where ugly, wicked, goblins lurked; and, way down, in darkest darkness, a lake of icy coldness where, on a slimy island of rock, lived Gollum – a treacherous, pale-eyed, hissing creature who made a horrible swallowing noise in his throat. It was here, in this dank, subterranean labyrinth, that Bilbo chanced upon a magic ring that gave the wearer the power of invisibility.

Gollum was just one of the many strange beings that hindered (and, very occasionally, helped) Bilbo and the Dwarves during their journey beyond the Edge of the Wild. There

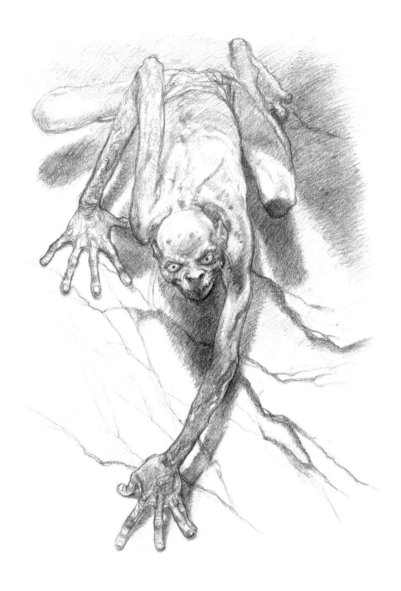

was the Great Goblin, huge-headed and bad-hearted; there were evil wolves, or Wargs, with blazing eyes and gnashing teeth; and there was the Lord of the Eagles who, with his brothers, came down from the sky like a huge black shadow to help the company at a moment of desperate danger. There was also Beorn, the skin-changer – sometimes a huge black bear, sometimes a great, strong, black-bearded man – who welcomed the travellers into his house where the air was full of the buzzing and whirring of bees and where they were waited upon by beautiful white ponies, long-bodied grey dogs and a large coal-black ram.

Less hospitable – especially after encountering the cob-webbed terrors of Mirkwood, with its loathsome army of pop-eyed, hairy-legged spiders – was the hall of the Elvenking who, wearing a crown of berries and red leaves, condemned the Dwarves to be held prisoner in his dungeon for having trespassed in his realm.

Beyond mountain and forest, they came first to Esgaroth (or Lake-town), the great wooden city built upon the Long Lake, and then to the dark and silent Lonely Mountain. On the mountain's western slopes, guided by Thror's map and the message of its moon-letters, Bilbo and the Dwarves found a secret door and a long, hot, smoky tunnel down into the lair of Smaug, the vast red-golden dragon who, with folded wings and huge coiled tail, lay upon a great mound of gold, gems and jewels.

Bilbo had a riddling conversation with Smaug – whom he addressed as the Chiefest and Greatest of Calamities – but, on discovering that there were intruders inside the Lonely Mountain and that they had received help from the Lake-men, the dragon became very angry and flew off to attack the town of Esgaroth. Shortly after reaching what is one of the most exciting parts of the story, Tolkien stopped writing; and, although he improvised an ending to the tale for his children, nothing more of *The Hobbit* was put down on paper.

Incomplete though it was, Tolkien showed the story – and the drawing of Thror's map – to some of his friends in Oxford, one of whom mentioned it to a representative from the publishing firm of George Allen and Unwin. As a result, the typescript was borrowed and read, and Tolkien was soon being encouraged to finish the tale so that it might be considered for publication.

Tolkien set to work again, writing about the bitter arguments which the Dwarves had with the Lake-men of Esgaroth and the Elves of Mirkwood over the dragon's treasure. Then he swiftly brought the story to a breathtakingly exciting climax in which a vast army of marauding goblins, wolves and Wargs attacked the Lonely Mountain, and Dwarves, Men and Elves were forced to unite against a common enemy in a terrible conflict that came to be known as the Battle of Five Armies.

At long last, in October 1936, the completed typescript was delivered. Stanley Unwin, chairman of the publishing company, asked his young son, Rayner, to read the book and write a report on it; this he did, ending with the opinion:

'This book, with the help of maps, does not need any illus-
trations it is good and should appeal to all children between
the ages of 5 and 9.' Master Unwin – who was ten! – was
paid one shilling (the equivalent of five pence) for his views
on a book that has since become a world-wide best-seller!

Rayner Unwin may have been happy to make do without
illustrations, but his father decided to ask the author to draw
and paint some pictures for the book. Tolkien also designed
a dustjacket which he decorated with runes. *The Hobbit, or
There and Back Again* was published in 1937.

There were also the maps. One, drawn in black and red,
showing Wilderland and the places where Bilbo's adventures
happened; the other was a copy of Thror's map, which the
author wanted to have printed in the first chapter of the
book, at the point at which Gandalf shows the map to Bilbo
and the Dwarves. Smaug, the inscription (signed with the
.ᚦᚦ. runes representing the initials of Thrór and his son,
Thráin) and the secret door (marked ᚾ with the rune for
'D') were printed in red.

These runes – which had caught the imagination of Bilbo
who 'loved maps' and 'liked runes and letters and cunning
handwriting' – were, in Tolkien's words, 'old letters originally
used for cutting or scratching on wood, stone, or metal, and
so were thin and angular.' Some years after the publication
of *The Hobbit*, he wrote to a friend giving a key which could
be used to read the runes. You will find Tolkien's letter (and
a translation) on the next page:

PROFESSOR TOLKIEN
MERTON COLLEGE
OXFORD

3, MANOR ROAD
OXFORD
Telephone : 47106

*TH*RE MANOR ROAD

SUNDAY NOV[E]MBER

*TH*E *TH*IRTIE*TH*

D*EAR* MRS FARRER: OF COURSE I WILL SIGN YO

UR COPY OF *TH*E HOBBIT. I AM HONOURED BY *TH*E

RECWEST. IT IS GOOD NEWS *TH*AT *TH*E BOOK IS OBTAIN

ABLE AGAIN. *TH*E NEXT BOOK WILL CO[N]TAIN MORE D

ETAILED INFORMATION ABOUT RUNES AND O*TH*ER

ALFABETS IN RESPO[N]SE TO MANY ENCWIRIES. IN

*TH*E MEΛNTIME WHILE *TH*E GRE*A*T WORK IS BEI*N*G FINIS[H]

ED I WONDER IF YOU WOULD LIKE A PROPER

KEY TO THE SPECIAL DWAR VIS[H] ADAPTATION

OF *TH*E E*N*GLIS[H] RUNIC ALFABET ONLY PART OF

WHICH A*PP*EARS IN *TH*E HO*BB*IT INCLUDI*N*G *TH*E COVER.

WE ENIOYED LAST MONDAY EUENI*N*G VERY MU

CH AND HOPE FOR A RETURN MATCH SOON.

YOURS SINCERELY

J. R. R. TOLKIEN

As for the secret moon-letters, Tolkien had asked for them to be printed using 'invisible lettering', but the publishers thought this too expensive and, eventually, the map (with the moon-letters completely visible) appeared as the front end-paper to the book.

71

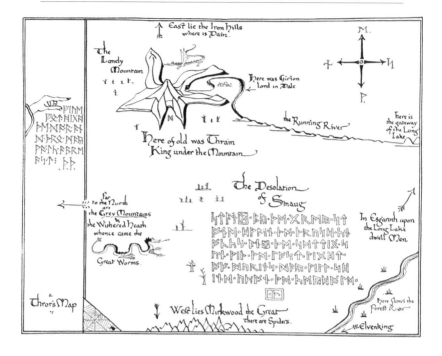

At the end of *The Hobbit*, Gandalf tells Bilbo: 'You are a very fine person, Mr Baggins, and I am very fond of you; but you are only quite a little fellow in a wide world. . .' However, when J. R. R. Tolkien had first written the line: 'In a hole in the ground there lived a hobbit,' he had not realised quite how *wide* a world it was. Although the only name that is given to the land where Bilbo's adventures take place is 'Wilderland', it was most certainly part of the imaginary realm of Middle-earth, which Tolkien had begun to create in 1917. What is more, Bilbo's escapades turned out to be only a prologue to a more ambitious story. . .

The book was so successful that Tolkien's publishers were soon asking for 'another book about the Hobbit' and, three

months after the publication of *The Hobbit*, he began to write just such a book. Where *The Hobbit* had begun with a chapter called 'An Unexpected Party', the new book, which would become *The Lord of the Rings*, was to open with a chapter entitled 'A Long-Expected Party', in which Bilbo used his magic ring to disappear at his own eleventy-first birthday party.

The ring proved to be far more powerful than anyone could have guessed from reading *The Hobbit*: it was one of several rings of great power, and had been forged by the Dark Lord Sauron (who had been referred to in *The Hobbit* as 'the Necromancer') in order to control the people of Middle-earth – Elves, Dwarves and mortal men. This ring, however, was the One Ring that controlled all the others.

When Bilbo left the Shire, the Ring passed to his adopted nephew and heir, Frodo Baggins, who was soon caught up in another perilous adventure, this time journeying south to the shadow-filled Land of Mordor, in order to destroy the Ring and Sauron's power.

As with *The Hobbit*, maps were an important part of *The Lord of the Rings* and since, as Tolkien had said, it is impossible to make a map of a story after it has been written, he made, adapted and amended them as he went along.

With them, it is possible for readers to follow the journeys of Bilbo and Frodo Baggins – there and back again.

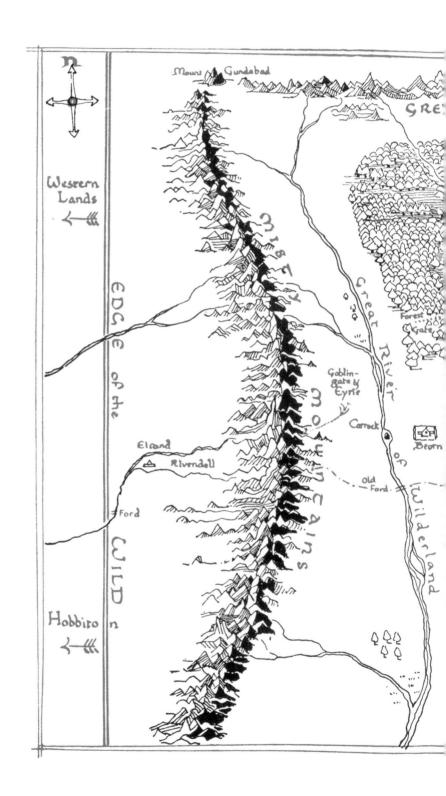

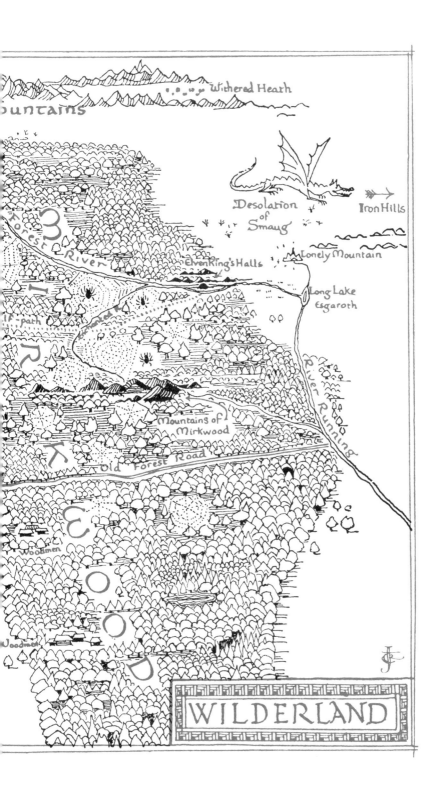

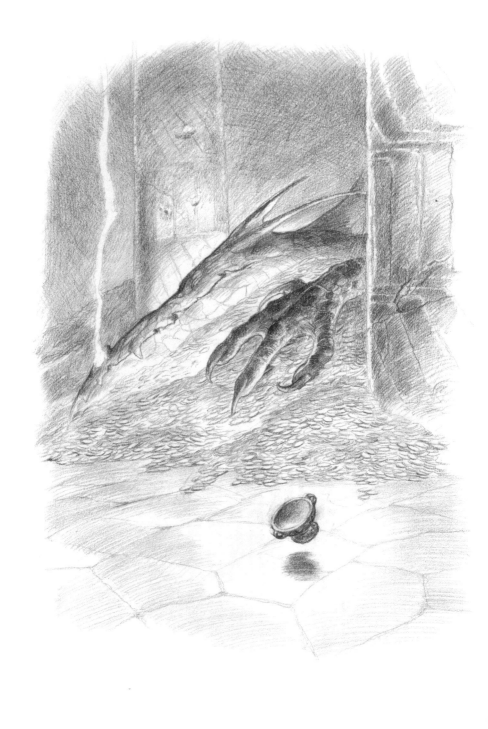

PLACES ON THE MAP
OF WILDERLAND

BEORN'S HOUSE, between the CARROCK and
MIRKWOOD, surrounded by a high thorn-hedge and
approached through a broad wooden gate, was a cluster of
low, wooden, thatched buildings – a house, barns, stables,
sheds and row upon row of straw bee-hives. This was the
home of Beorn, a giant of a man with a thick black beard
and hair, great bare arms and legs with knotted muscles,
who could change his shape into that of a bear. In Beorn's

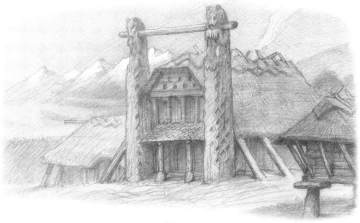

hall – lit by beeswax candles and with a fireplace in the middle – the travellers were served food and bowls of mead by Beorn's animal attendants.

CARROCK, a great rock – 'almost a hill of stone, like a last outpost of the distant mountains' – set in the Great River fifty miles north of the OLD FORD. It was named by Beorn, the shape-changer, who called it '*the* Carrock' because it was the only such rock near his home and he knew it well; indeed, he had cut steps into its steep side. Gandalf remembered having seen Beorn sitting there one night watching the moon sinking towards the MISTY MOUNTAINS and growling in the tongue of bears.

DESOLATION OF SMAUG, the land around Erebor, the LONELY MOUNTAIN. Laid waste by the dragon, Smaug, it had little grass and no bushes nor trees other than broken and blackened stumps.

ELF-PATH, the way through MIRKWOOD taken by Bilbo and his companions. The path was narrow and wound in and out among the tree trunks and was crossed by the ENCHANTED RIVER. 'Don't stray off the track!' warned Gandalf, 'if you do, it is a thousand to one you will never find it again and never get out of Mirkwood. . .'

ELVENKING'S HALLS, were secured by huge doors of stone and comprised a great cave (within the edge of MIRKWOOD) from which countless smaller ones opened out on every side leading, far underground, to winding passages and wide halls. It was here that the Elvenking imprisoned the

Dwarves in his dungeon and from which, with Bilbo's help, they escaped by barrel down the FOREST RIVER.

ENCHANTED RIVER, black and strong, flowed through the gloom of MIRKWOOD. Beorn warned Bilbo and his companions against drinking or bathing in the stream since it carried an enchantment and 'a great drowsiness and forgetfulness'. Despite this warning, one of the Dwarves, Bombur, fell into the river and under its spell.

ESGAROTH (LAKE-TOWN), a town of many buildings, with wooden quays from which many steps and ladders went down to the surface of the lake, built upon tall piles

driven into the bed of the LONG LAKE. It was here that Bilbo and the Dwarves came after their escape from the dungeon of the Elvenking. Later, Lake-town was attacked by Smaug the dragon and was set ablaze by the terrible flames of his breath. However, a single arrow, fired by Bard the Bowman, brought Smaug crashing down in ruin upon the burning town.

EYRIE, a Great Shelf high on the eastern slopes of the MISTY MOUNTAINS to which the Lord of the Eagles and his brothers carried the travellers after having rescued them from goblins and Wargs.

81

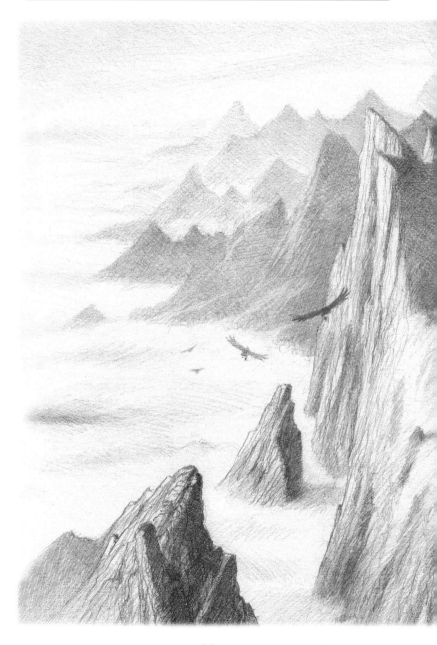

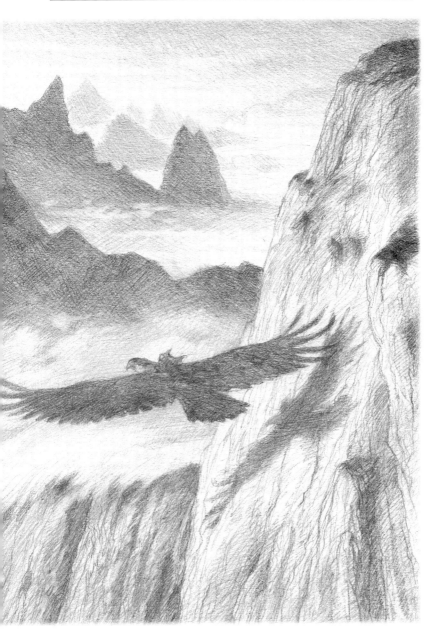

FOREST-GATE, an arch made by two great trees – old, strangled with ivy and hung with lichen – that, leaning together, formed the entrance to MIRKWOOD. Beyond lay a gloomy tunnel where the ELF-PATH wound away into the dark stillness of the forest.

FOREST RIVER, running south-east from the GREY MOUNTAINS, through the northern part of MIRKWOOD, past the ELVENKING'S HALLS and into the LONG LAKE. It was down this river to ESGAROTH that the Dwarves travelled, hidden inside barrels, and so escaped from their imprisonment in the dungeon of the Elvenking.

GOBLIN GATE, the 'back-door' to the goblin kingdom on the east side of the MISTY MOUNTAINS. It had been built both as an escape route (if needed) and as a way out into the lands beyond the mountain range, where the goblins sometimes journeyed in order to plunder, murder and enslave.

GREAT RIVER OF WILDERLAND, flowing south from the GREY MOUNTAINS and named Anduin in *The Lord of the Rings*, where the story of the river's importance in the history of Middle-earth is fully told. It was in the waters of the Great River that the One Ring, which had been cut from the hand of Sauron and was now worn by Isildur, slipped from the wearer's finger and was lost. It was later found by a hobbit-like creature called Déagol and who was murdered by his friend, Sméagol, who wanted the ring for himself. Calling it his 'precious', Sméagol took the

ring and went to live among the dark passageways under the MISTY MOUNTAINS. It was there that Sméagol, then known by the name Gollum, lost the magic ring once more and encountered Mr Bilbo Baggins, who had accidentally found it.

GREY MOUNTAINS of the north were never visited by Bilbo and the Dwarves, but Gandalf warned them against travelling in that direction, saying that their slopes were 'simply stiff with goblins, hobgoblins, and orcs of the worst description'.

IRON HILLS, settled by the Dwarves of Durin's Folk after their lands to the west had been laid waste by dragons. It was from here that Dáin led an army of five hundred Dwarves to the LONELY MOUNTAIN to aid Thorin in the struggle which became known as the Battle of Five Armies.

LONELY MOUNTAIN (or Erebor, as it is named on the maps of Middle-earth) was discovered by the ancient Dwarf lord, Thráin the Old. It became the home of Thrór and his family when they were driven out of the far north. Here Thrór became King under the Mountain and, living in peace with the men who dwelt along the banks of the RIVER RUNNING, the Dwarves added to their considerable fortune with gold and gems discovered under the mountain. The Dwarves worked as smiths, making objects of great beauty and delightful playthings for the nearby town of Dale, where the toy market became the wonder of the north.

It was Thror's great wealth that brought the greedy, strong and wicked dragon, Smaug, down from the north. Those Dwarves who did not escape were destroyed by Smaug, who crawled in through the Front Gate and made his lair among the treasure-filled halls beneath the mountain. Occasionally, the dragon emerged and terrorized the town of Dale, from whose people, years later, would come the dragon-slayer, Bard the Bowman. It was before this

same Gate that the Dwarves, the
Elves of MIRKWOOD and the
men of ESGAROTH fought the
Battle of Five Armies against the
goblins and Wargs of the north.

LONG LAKE, on which the Lake-men
had built the Lake-town of ESGAROTH.

MIRKWOOD, a dense forest between the
GREAT RIVER and the LONELY MOUNTAIN,
described by Bilbo as having 'a sort of watching and wait-
ing feeling'. Entering by the FOREST-GATE, the travellers
followed the ELF-PATH through the still, dark and stuffy
wood with its tall trees, between which great spiders had
stretched cobwebs made of thick, sticky threads.

It was in this wood that they crossed the ENCHANTED
RIVER, saw the Wood-elves feasting among the trees to
the sound of song and harp, were attacked by an army
of huge, ugly spiders and were eventually captured and
led off to the ELVENKING'S HALLS.

On the southern edge of Mirkwood (not shown on this
map, but on the map of Middle-earth) stood Dol Guldur,
at one time the the fortress of the Necromancer (later
known as Sauron, the Lord of the Rings) in whose dungeon
Thorin Oakenshield's father, Thráin, was held prisoner.

MISTY MOUNTAINS, a great mountain range running north
to south in Middle-earth. Setting out from RIVENDELL,
Gandalf, Bilbo and the Dwarves attempted to cross the

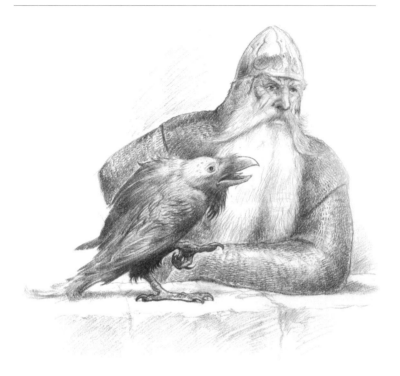

mountains but were prevented by bad weather. They sheltered from the storm in a cave which proved to be a secret entrance to the goblin kingdom beneath the mountains. The company were seized by goblin soldiers, but Gandalf, who had remained free, attacked the goblins with magic fire and killed the Great Goblin with his sword. In the struggle that followed, Bilbo was separated from his friends and, wandering lost through the maze of passageways, came to a dark lake. Here Bilbo encountered Gollum and accidentally found the slimy creature's 'precious', the magic ring that could make the wearer invisible.

It was in the Mines of Moria, beneath the southern

arm of these mountains (not shown on this map), that the Dwarf Thorin Oakenshield's grandfather Thrór was killed by Azog the Goblin and where, many years later, Frodo and his companions were to have desperate adventures as recounted in *The Lord of the Rings*.

MOUNT GUNDABAD, the goblin capital in the north where, on learning that Smaug the dragon had been killed and that the Dwarves had returned to the LONELY MOUNTAIN, a vast army gathered by many secret ways, planning to sweep down, storm the mountain and seize the Dwarves' treasure.

OLD FORD, across the GREAT RIVER, fifty miles south of the CARROCK.

OLD FOREST ROAD, once the highway from the High Pass over the MISTY MOUNTAINS, crossing the GREAT RIVER at the OLD FORD, but which, by the time Bilbo and the Dwarves were journeying eastward, had been abandoned as impassable and as a route endangered by the presence of goblins.

RIVENDELL, a hidden valley beyond the Edge of the Wild, where the scent of trees was in the air and where a narrow bridge led to the Last Homely House. It was at Rivendell that the travellers rested before setting out to cross the MISTY MOUNTAINS and where Elrond, the master of the house, deciphered the moon-letters written on Thror's map.

RIVER RUNNING, or Running River, which flowed south from the LONELY MOUNTAIN. In *The Lord of the Rings*, the river's Elvish name is given as Celduin, and maps of Middle-earth show it as running into the Sea of Rhûn.

WITHERED HEATH, the region from which came the dragons that plagued the Dwarves of Durin's folk dwelling among the mountains of the north.

For the Map of Beleriand, I turned to J.R.R. Tolkien's own painstaking renderings of his exquisite Elvish heraldry to enhance the decorative border, which also owes a great debt to the work of Archibald Knox, the Manx artist and designer. The landscape at the bottom is more or less the view we enjoyed from our temporary home in Wellington, New Zealand, while working on the Lord of the Rings trilogy. Naturally, the ships going to and fro were largely freighters, or ferries carrying passengers between the North and South Islands, and undisputedly, seagulls vastly outnumbered swans. The painting was done in Wellington, in those spare moments not devoured by film work. As for the three swans, they are a recurring symbol in much of my work, symbolizing journeys and quests.

While doing the map, I regretted not having had more occasions to explore Beleriand in illustrations. I certainly plan to remedy this in the future.

John Howe

WEST OF THE MOUNTAINS, EAST OF THE SEA:

About the Map of Beleriand

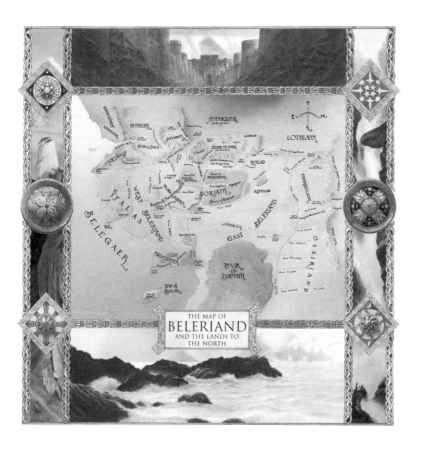

'In Beleriand in those days the Elves walked, and the rivers flowed, and the stars shone, and the night-flowers gave forth their scents.'

'In those days. . .' With that one phrase, J. R. R. Tolkien evoked the haunting mystery of the lands shown on this map. For this is a map from the past, from the world's First Age. The place is Middle-earth – that ancient continent where the adventures chronicled in *The Hobbit* and *The Lord of the Rings* took place – but the names were old long before Bilbo Baggins set out on his memorable journey 'there and back again' or his adopted heir, Frodo, embarked on his perilous quest to destroy the One Ring.

Indeed, by Bilbo and Frodo's time, the Beleriand of 'those days' had long disappeared, sunk beneath the seas so that only its far eastern regions remained as the western coast of the world known to the hobbits. There were those who remembered the lands of Beleriand, and for some it was their destiny to play a part in the tale of the Ring-bearers from the Shire: Treebeard, Elrond, Galadriel and Celeborn as well as Sauron, the Dark Lord himself, whose tyrannical

shadow stretched across the lands on this map long before he established his fearful stronghold in Mordor.

It was in 1914, that J. R. R. Tolkien wrote a poem entitled 'The Voyage of Éarendel the Evening Star', and then began to think about the world where the story told in the poem might have taken place. Three years later, he embarked on the creation of an epic fantasy, a new and entirely original mythology. In the pages of a humble notebook the extraordinary *Book of Lost Tales* started to take shape: a series of

connected stories aimed at providing what Tolkien felt to be lacking in the legends of England.

This was the beginning of a slow, complex creative process that eventually resulted in the history of Middle-earth, but which involved the devising of languages and alphabets, the setting down of dates and genealogies as well as the essential task of making maps.

Tolkien was a student of old languages and a lover of myths, legends and fairy-stories, and his own stories grew and multiplied like the leaves of a tree in springtime. Developing into a majestic cycle of interconnected legends, Tolkien's *Lost Tales* soon outgrew the notebook in which they were begun.

'The Silmarillion', as it came to be called, was constantly being added to and revised, until it acquired all the authenticity that comes with the minute – and sometimes conflicting – detail of *real* history. And for Tolkien, who believed that fantasy could offer 'a sudden glimpse of the underlying reality or truth', Middle-earth *was* real.

The labour of chronicling these tales would take almost sixty years, during which time Tolkien became an Oxford professor and wrote *The Hobbit*, an adventure – as it later transpired – which took place within the realm of Middle-earth described in 'The Silmarillion'.

When the eager publishers clamoured for a sequel to *The Hobbit*, Tolkien hopefully sent them parts of his epic myth which, at the time, they rejected. He then began work on another book, about the later fate of the One Ring which Bilbo had acquired in *The Hobbit*; but relating this new story to those in 'The Silmarillion' required a lot more thought

before *The Lord of the Rings* finally reached publication in 1954 and 1955.

As for 'The Silmarillion', Tolkien continued revising and expanding the work until his death in 1973, at which time it was still incomplete. It was finally published four years later, edited into shape by Christopher Tolkien, who over the next four decades edited many further volumes charting his father's history of Middle-earth. *The Silmarillion* also contained a map of Beleriand drawn by Christopher from his father's drafts, which inspired John Howe to create his interpretation of those lands west of the mountains and east of the sea.

Every map is as potentially frustrating as it is helpful: either it will be drawn on a small scale which enables all the major geographical features to be included, but not much detail; or it will use a larger scale that makes it possible to put in lots of places and names but excludes vast territories beyond its edges.

The map of Beleriand falls into the second category, since it shows only a part of the world described in the early history of Middle-earth, and that during a comparatively short phase of its life. For example, there is no depiction of the island kingdom of Númenor, located between Middle-earth and the Undying Lands beyond the western sea, nor of those regions to the east which later appear in *The Hobbit* and *The Lord of the Rings*.

What the map of Beleriand *does* show (with the exception of the most northerly lands) are all those kingdoms in Middle-earth that were caught up in the devastating War

of the Jewels that was waged, across many years, for the possession of the Silmarils, the three great gems which give 'The Silmarillion' its title.

To understand that lengthy conflict, however, it is necessary to know something of the events that had gone before, even though many of the places where they occurred are not depicted on this map.

In the beginning, Eru Ilúvatar, the Father of All, called into being the Ainur, or the Holy Ones, who joined with Ilúvatar in creating a Great Music in which the wondrous themes of Ilúvatar were interwoven with variations – some harmonious, some dissonant – devised by the Ainur.

Ilúvatar then gave substance to the music and from it made first Eä, the World, and Arda, the Earth. After which he gave form to his Children who were to dwell on Earth: Elves and Men, known as the Firstborn and the Followers.

Out of their love for Ilúvatar and his creation, some of the Ainur chose to go down into the World, to become part of its life and to watch over the destiny of Ilúvatar's Children. These were the Valar, the Powers of the World, and foremost amongst them was Manwë and his queen, Varda Tintallë, the Star-kindler, who was later remembered in song by the Elves in *The Lord of the Rings*, as Elbereth Gilthoniel.

Whilst the Valar helped shape and bless the realm of Arda, one of their number, the rebellious Melkor, did his best to corrupt or destroy their work and to bend the creation to his own will. Despite every effort of the Valar, Melkor continued to build his strength in his dark stronghold, Utumno, where he bred many monstrous creatures.

Eventually the Valar went forth in force against Melkor and, after a lengthy siege, overthrew Utumno. Melkor was chained and taken to Valinor where he was tried and imprisoned in the halls of Mandos, from which there was no escape. After three ages had passed, however, Melkor – full of deceit – pleaded for his forgiveness and was pardoned. Then, in his anger and hatred, he began plotting his revenge, aided by his evil servants – among them his lieutenant, Sauron the Abhorred.

The Valar left Middle-earth for Aman, beyond the Sea of Belegaer in the west, where they founded their own kingdom. This became the Blessed Realm of Valimar, illuminated by the radiance of the Two Trees, Telperion and Laurelin. Then the Valar summoned the Elves (who, unlike Men, were intended by Ilúvatar to be immortal), to travel across Middle-earth to the sea, from where they would be taken to the Undying Lands in the west.

Some of the Elves made the journey, some refused, while others turned aside from the long road to linger by the Great Water, or to wander under the light of Varda's stars amongst the woods and mountains of Middle-earth.

The three kings of the Elves who went into the west to Aman were Ingwë King of the Vanyar, Olwë King of the Teleri and Finwë King of the Noldor. Finwë's eldest son, Fëanor, was to become the greatest of the Elves in arts and lore and it was he who made three magnificent Jewels, the Silmarils, in which he captured the light of the Two Trees of Valinor. But the envious Melkor, aided by a monstrous spider named Ungoliant (ancestor of Shelob in *The Lord of*

100

the Rings), killed the Two Trees, murdered Finwë and stole the Silmarils.

Against the counsel of the Valar, Fëanor led a great host of Elves in pursuit of Melkor, whom he renamed Morgoth, the Black Foe of the World. The way back to Middle-earth was fraught with many evils and the first of several wicked partings, betrayals and kin-slayings took place: acts of ruthlessness and greed that turned Elf against Elf and furthered Morgoth's dark purposes.

The returning Elves encountered not only those of their number who had remained in Beleriand but also the Followers, the race of Men (who like them had awoken in the lands to the east), and the Dwarves who had been shaped by Aulë, one of the Valar, but who were given life itself by Ilúvatar. The Elves made alliances with the Men and called upon the skills of the Dwarves in the making and rich decoration of their many-pillared underground halls as well as in the fashioning of exquisite jewellery and mighty weapons.

The Wars of Beleriand, in which the Elves and their allies fought the forces of Morgoth, are recounted in *The Silmarillion* along with the stories of Beren and Lúthien, who entered Morgoth's stronghold and took back one of the Silmarils, and of the doomed Túrin Turambar, who slew Glaurung, a fearsome dragon who served Morgoth.

As with the stories in *The Hobbit* and *The Lord of the Rings*, the events recorded in *The Silmarillion* are closely connected with – and shaped by – the physical geography of the world in which they take place.

There were the mountains: long, unbroken chains of rock. Some, like the sheer-sided peaks of Crissaegrim, were inaccessible to all but Manwë's eagles; others, such as the Blue Mountains (Ered Luin), might – with effort – be scaled. It was across this range that the Children of Ilúvatar first entered Beleriand while, in its eastern walls, the Dwarves delved marvellous citadels.

While some of Middle-earth's loftiest crests offered protection – such as the Encircling Mountains which hid the secret Elven city of Gondolin from the searching gaze of Morgoth – others, by their very names, spoke of danger and menace: the three thunderous towers, belching smoke and

reek, called the Mountains of Tyranny (Thangorodrim), reared by Morgoth above the gate of the endless dungeons of Angband, as a defiant symbol of his authority. Or the Mountains of Terror (Ered Gorgoroth) beneath which, in shadowy ravines and gullies, the spider, Ungoliant, and her children lurked in the gloom, spinning their nightmarish webs.

There were also great hills. Sites of encampments and lookouts, places of refuge and hiding, these solitary sentinels stood amid windswept plains or raised their heads above the dense canopies of forests.

The woods of Beleriand – like those described in the other chronicles of Middle-earth – could be places of profound mystery, enduring power and deep enchantment. It was in a glade of the forest Nan Elmoth that Thingol the Elf (then named Elwë), heard the singing of Melian of the race of the Valar and was filled with wonder and love.

Thingol wed Melian and ruled the woodland realm of Doriath from Menegroth, the Thousand Caves. Melian cast an unseen wall of shadow and bewilderment around these forests to act as a girdle of protection for their realm. It was in Doriath's Forest of Neldoreth that a man, Beren, first saw Lúthien, daughter of Melian and

Thingol, and was captivated by her beauty and singing as she danced under moonrise beside the waters of the River Esgalduin.

There were many other rivers in Beleriand as well as vast lakes, treacherous marshlands, tarns, streams and rushing torrents. It was along the shore of the Firth of Drengist that Fëanor's returning Elves began their exploration of Middle-earth. It was beside the course of the River Ascar, far away in the east, that the Dwarves made the road by which they travelled from the Blue Mountains into the western lands. And it was along the rocky bed of the Dry River that a secret way was found to the hidden plain where Turgon built the mighty, white-walled city of Gondolin.

Many desperate deeds were acted out beside the rivers of Beleriand. In a deep gorge of the River Teiglin, Túrin fought and slew the dragon, Glaurung. Túrin was wounded in the struggle and when his sister-wife, Nienor, discovered his body, she supposed him to be dead and hurled herself into the Teiglin's rushing waters. It was also to this doomful site that the despairing Túrin later returned to kill himself.

The greatest of the rivers was the Sirion, flowing down from the mountains of the north, through forest and fen-land before cascading over falls and plunging beneath the ground to emerge with a roar of foam and spray at the Gates of Sirion.

On its northern course, the river divided around the island of Tol Sirion where Finrod Felagund built his Tower of Watch, Minas Tirith (a name also given, in a later age, to the City of Gondor). Seized by Sauron, the island became

known as the Isle of Werewolves, and it was here that Lúthien and Huan, the wolfhound of Valinor, battled to free Beren from Sauron's dungeons.

North and east of these mountains, woods and rivers lay lands defiled by Morgoth: the desolate plain of Anfauglith, the Gasping Dust, and the burnt highlands of Taur-nu-Fuin, where the trees were black and grim with tangled roots groping in the dark like claws; devastated wastes, foreshadowing Sauron's Mordor in *The Lord of the Rings*.

And *beyond* the lands of Beleriand lay the Western Sea and the watery road to those places not shown on this map: Elven Eressëa, Alqualondë and Tirion of the many towers and, beyond them, Valimar the golden, where in the days of darkest struggle with Morgoth, Eärendil the Mariner came as emissary of both Elves and Men to ask the Valar for deliverance. The Valar sent Eärendil to sail the seas of heaven with Lúthien's Silmaril shining on his brow as a star, and his prayer for aid was granted. Thus began the War of Wrath, in which most of the lands on this map were lost beneath the invading ocean, so that the Elves of story and song walked in Beleriand no more.

In one of the early chapters of *The Lord of the Rings*, Frodo hums an old walking-song taught to him by his uncle, Bilbo. One verse begins:

> *Still round the corner there may wait*
> *A new road or a secret gate,*
> *And though we pass them by today,*

Tomorrow we may come this way
And take the hidden paths that run
Towards the Moon or to the Sun...

They are words that reflect the sense of adventure – with its pleasures and perils, sudden excitements and unexpected dangers – found in all Tolkien's books and which drove him to keep exploring, and then mapping, the worlds which his imagination had discovered.

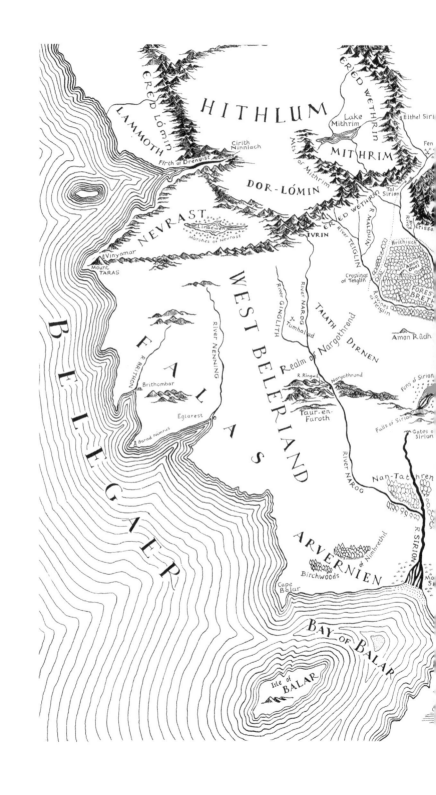

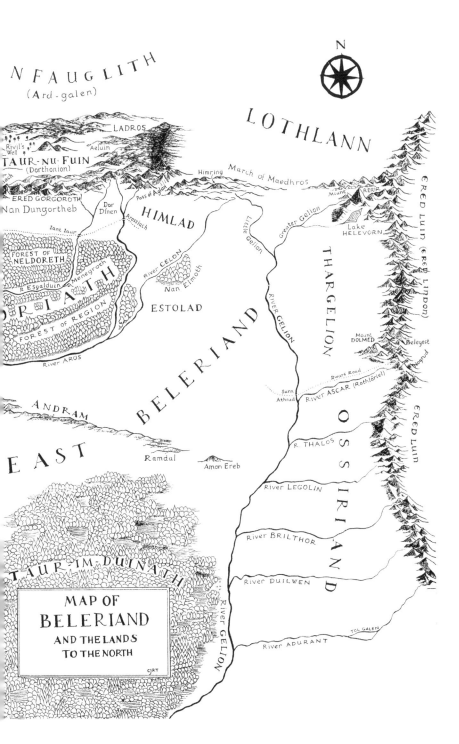

DOR-NU-FAUGLITH
(Ard-galen)

LOTHLANN

LADROS

Rivil's Well

Aeluin

TAUR-NU-FUIN
(Dorthonion)

Himring

March of Maedhros

Mount RERIR

ERED GORGOROTH

Nan Dungortheb

Dor Dínen

Pass of Aglon

HIMLAD

Little Gelion

Greater Gelion

Lake HELEVORN

ERED LUIN (ERED LINDON)

Iant Iaur

Arossiach

FOREST OF
NELDORETH

Menegroth

River CELON

Nan Elmoth

River GELION

THARGELION

R. Esgalduin

DORIATH

FOREST OF REGION

ESTOLAD

Mount DOLMED

Belegost

River AROS

Nogrod

ERED LUIN

ANDRAM

BELERIAND

Dwarf Road

Sarn Athrad

River ASCAR (Rathlóriel)

EAST

Ramdal

Amon Ereb

R. THALOS

OSSIRIAND

River LEGOLIN

River BRILTHOR

River DUILWEN

TAUR-IM-DUINATH

River GELION

River ADURANT

TOL GALEN

MAP OF
BELERIAND
AND THE LANDS
TO THE NORTH

CJRT

PLACES ON THE
MAP OF BELERIAND

ADURANT, 'Double Stream'; the sixth and most southerly of the tributaries of the River GELION, which divided – midway along its course – around the island, TOL GALEN.

AELIN-UIAL, 'The Meres of Twilight'; the lakes south of the meeting place of the Rivers AROS and SIRION.

AELUIN, see TARN AELUIN

AGLON, see PASS OF AGLON

AMON EREB, 'The Lonely Hill', where Denethor, a lord of the Laiquendi, or Green-elves, of Ossiriand, and all his nearest kin died aiding Thingol in the first of the Wars of Beleriand against Morgoth's Orcs, and where Maedhros dwelt after the Fifth Battle.

AMON OBEL, a hill in the middle of the Forest of BRETHIL where, at Ephel Brandir ('The encircling fence of Brandir') lived the Men of Brethil. Túrin dwelt here and married Nienor, not knowing that she was his sister.

AMON RÛDH, 'The Bald Hill', to the south of BRETHIL, beneath which was the cavern home of Mîm the Petty-dwarf. It was here that Túrin and the outlaw band lived and were joined by Beleg, Thingol's marchwarden from DORIATH. Attacked by Morgoth's Orcs, Beleg was wounded and Túrin taken prisoner.

ANACH, see PASS OF ANACH

ANDRAM, 'The Long Wall'; a range of hills – running west to east from NARGOTHROND to RAMDAL – forming a dividing escarpment between the northern and southern regions of BELERIAND.

ANFAUGLITH, 'The Gasping Dust'; a great desert to the north, originally called ARD-GALEN ('The Green Region'), but renamed after its devastation by Morgoth. To its north, but not shown on this map, was Morgoth's underground stronghold, Angband, where he forged the iron crown in which he set the Silmarils stolen from Fëanor of the Elves. For a time Angband was unroofed by the Valar, but Morgoth delved it anew and raised the threefold peaks of Thangorodrim in its defence. Fingolfin, High King of the Noldor, was slain in a duel with Morgoth before its gates; while in its deepest hall, Beren and Lúthien cut one of the Silmarils from Morgoth's crown. After the overthrow of Morgoth in the 'Great Battle', the two remaining Silmarils were stolen by Maedhros and Maglor, before being cast away: one into a chasm of fire, the other into the sea.

ARD-GALEN, 'The Green Region'; later renamed
ANFAUGLITH.

AROS, river flowing from DORTHONION along the south-
ern borders of DORIATH to join the River SIRION at
AELIN-UIAL.

AROSSIACH, 'The Fords of Aros', used by Aredhel
and Maeglin when they fled from Eöl the Dark Elf to
GONDOLIN.

ARVERNIEN, the coastal lands of Middle-earth west of the MOUTHS OF SIRION.

ASCAR, river (later called Rathlóriel), beside which ran the DWARF ROAD. Rising in ERED LUIN, it joined the River GELION south of SARN ATHRAD.

BARAD NIMRAS, 'White Horn Tower', built by Finrod Felagund on the cape to the west of EGLAREST to keep watch against invasion from the sea. The tower eventually fell, following the Fifth Battle, to a land attack by Morgoth.

BAY OF BALAR, broad bay at the outlet of the River SIRION.

BELEGAER, 'The Great Sea' between Middle-earth and Aman, the Blessed Realm, where the Valar dwelt in Valinor.

114

BELEGOST, 'Great Fortress'; one of two Dwarven cities (with NOGROD) built in the eastern walls of ERED LUIN and known to the Dwarves as Gabilgathol.

BELERIAND, the name (meaning the 'the country of Balar') given first to the region around the MOUTHS OF SIRION facing the ISLE OF BALAR, but which later came to mean all those lands south of HITHLUM from the western sea-coast to ERED LUIN, divided into East and West Beleriand by the River SIRION. At the end of the First Age, Beleriand was broken by great upheavals and flooded by the sea. Only OSSIRIAND remained, eventually becoming the Forlindon and Harlindon depicted on the maps in *The Lord of the Rings.*

BIRCHWOODS OF NIMBRETHIL, see NIMBRETHIL

BRETHIL, forest growing between the Rivers TEIGLIN and SIRION which became the home of the men known as the Haladin, or the People of Haleth.

BRILTHOR, 'Glittering Torrent'; the fourth tributary of the River GELION.

BRITHIACH, a ford crossing the River SIRION north of the Forest of BRETHIL. Here Húrin and Huor were cut off by an army of Orcs until Ulmo, the Vala, raised a mist from the Sirion which hid them from their enemies and enabled them to escape into DIMBAR.

BRITHOMBAR, northern haven of the Falathrim, Telerin Elves (ruled by Círdan the Shipwright) who refused the

115

summons to Aman and became Middle-earth's first mariners. The city was sacked by Morgoth's army following the Fifth Battle.

BRITHON, river flowing down to the Great Sea at BRITHOMBAR.

CAPE BALAR, a promontory in the BAY OF BALAR, facing south towards the ISLE OF BALAR.

CELON, river rising at HIMRING (its name means 'stream flowing down from the heights') flowing south-west, past NAN ELMOTH, to join the River AROS by the Forest of REGION.

CIRITH NINNIACH, 'Rainbow Cleft'; the route by which Tuor came to the Western Sea after leaving the caves of Androth.

CRISSAEGRIM, a range of inaccessible mountain peaks south of GONDOLIN. Here Thorondor, King of the Eagles, built his eyries and, seeing Húrin and Huor wandering lost below the southern slopes, sent two eagles to carry them to the hidden city. Later, following his release from Angband, Húrin returned to these peaks in an unsuccessful attempt to find his way to Gondolin once more.

CROSSINGS OF TEIGLIN, the point at which the old road running south from the Pass of SIRION crossed the River TEIGLIN. Here Túrin encountered Nienor (who was under an enchantment of the dragon, Glaurung) and fell in love with her without knowing that she was his sister.

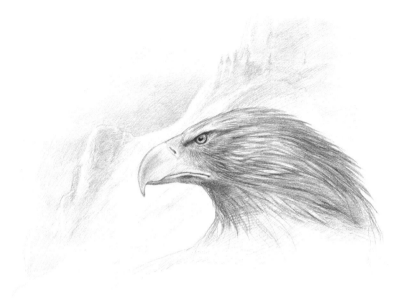

DIMBAR, an uninhabited region south of the peaks of CRISSAEGRIM.

DOLMED, see MOUNT DOLMED

DOR DÍNEN, 'The Silent Land'; an empty region between the upper waters of the Rivers ESGALDUIN and AROS.

DORIATH, 'Land of the Fence', a name referring to its girdle of protecting enchantment; the greatest realm of the Sindar, comprising chiefly the Forests of NELDORETH and REGION and ruled by Thingol and Melian. Visiting Doriath's city of MENEGROTH inspired Finrod to build his own city of NARGOTHROND. In Doriath too Finrod's sister, Galadriel, met Celeborn with whom she later ruled in Lórien, as is told in *The Lord of the Rings*. On Doriath's

borders Lúthien encountered the wolfhound, Huan, with whose aid she rescued Beren from Sauron's dungeons in Tol-in-Gaurhoth. It was also in Doriath that Huan fought Morgoth's wolf, Carcharoth, and – after the Silmaril had been recovered – Beren met his first death.

DOR-LÓMIN, region in the southern part of HITHLUM. The territory of Fingon, son of Fingolfin, its lordship was given to Hador Lórindol of the race of Men.

DORTHONION, 'The Land of Pines'; stretching sixty leagues from east to west, this highland was held by Angrod and Aegnor, Finarfin's sons, and was later known as TAUR-NU-FUIN, 'The Forest under Nightshade'. It was taken by Morgoth's forces in the Fourth Battle (known as the Battle of Sudden Flame). Many lives were lost, but Barahir, the father of Beren, rescued Finrod Felagund. In Treebeard's song, 'In the Willow-meads of Tasarinan', sung to Merry and Pippin in Fangorn, the Ent recalls visiting Dorthonion with the words, 'To the pine-trees upon the highland of Dorthonion I climbed in the Winter.'

DRY RIVER, the course of a river that once flowed under the Encircling Mountains from the lake that afterwards became Tumladen, the plain around the secret city of GONDOLIN. It was the hidden way by which Aredhel and her son, Maeglin, entered Gondolin, followed by her husband, Eöl, the Dark Elf, who killed his wife and was put to death in punishment.

DUILWEN, the fifth tributary of the River GELION.

DWARF ROAD, built by the Dwarves when they set out from the cities of BELEGOST and NOGROD to venture into BELERIAND. It ran alongside the River ASCAR and crossed the River GELION at SARN ATHRAD.

EAST BELERIAND, see BELERIAND

EGLAREST, southern haven of the Falathrim, the seafaring Elves of the FALAS. Like BRITHOMBAR, it was razed by Morgoth after the Battle of Unnumbered Tears.

EITHEL SIRION, 'Sirion's Well', in the eastern face of ERED WETHRIN. From hills near here, Fëanor's son, Celegorm, drove an army of Orcs into the FEN OF SERECH during the Second Battle in the Wars of BELERIAND. This was later the site of the Noldorin fortress, Barad Eithel, the 'Tower of the Well'.

ERED GORGOROTH, 'The Mountains of Terror', where 'life and light were strangled' and where the waters were so poisonous that anyone who drank from them would be 'filled with shadows of madness and despair'.

ERED LINDON, see ERED LUIN

ERED LÓMIN, 'The Echoing Mountains', pierced by the FIRTH OF DRENGIST.

ERED LUIN, 'The Blue Mountains' (also known as Ered Lindon), across which the Children of Ilúvatar, Elves and Men, entered BELERIAND from the east, to be followed, later, by the Dwarves who built their cities, BELEGOST and NOGROD, in the mountains' eastern side.

ERED WETHRIN, 'The Mountains of Shadow', bordering ANFAUGLITH and forming a barrier between south HITHLUM and West BELERIAND. Fëanor, mortally wounded by Gothmog, Lord of the Balrogs, was being carried up the slopes of these mountains when he saw the three peaks of Thangorodrim, cursed Morgoth and died.

ESGALDUIN, 'River under Veil', flowing from ERED GORGOROTH between the Forests of NELDORETH and REGION to join the River SIRION. On its eastern bank were the gates of MENEGROTH, approachable only by a great stone bridge. It was beside this river that Beren of the race of Men first saw Lúthien, daughter of Thingol and Melian.

ESTOLAD, 'The Encampment'; the land south of NAN ELMOTH where the Men of the followings of Bëor and Marach lived after entering BELERIAND from the east.

FALAS, the western coasts of BELERIAND south of MOUNT TARAS and north of ARVERNIEN, on which stood the havens of BRITHOMBAR and EGLAREST.

FALLS OF SIRION, the waterfall where the River SIRION plunged from AELIN-UIAL to disappear into great tunnels before emerging, three leagues to the south, at the GATES OF SIRION.

FEN OF SERECH, marsh at the confluence of the Rivil and the SIRION, north of the Pass of SIRION. Here Fëanor's son, Celegorm, defeated an army of Orcs; and

it was behind this fen, during the Fifth Battle, Nirnaeth Arnoediad (also known as the Battle of Unnumbered Tears), that Huor and Húrin made their last stand to guard the retreat of Turgon to GONDOLIN. Huor was slain, but Húrin was captured and dragged with mockery to Angband where Morgoth set him upon a stone seat on the side of Thangorodrim to witness the ruin of BELERIAND.

FENS OF SIRION, marshlands south-west of DORIATH around the pools of AELIN-UIAL.

FIRTH OF DRENGIST, a northern inlet of the Great Sea. Its mouth was where Fëanor's Noldor, pursuing Morgoth from Aman, disembarked from the ships that they had stolen from the Teleri. At Losgar (not shown) Fëanor burnt the ships thinking to keep Fingolfin and the children of Finarfin from following him: but his betrayed kindred came to Middle-earth despite him, crossing the sea on the ice-floes of the Helcaraxë. Years later, King Fingon of HITHLUM surprised an army of Orcs at the head of the firth and drove them into the sea; and when, long afterwards, Fingon was again battling Orcs, but was outnumbered, it was up this firth that Círdan the Shipwright led a fleet of Elves of FALAS putting Morgoth's army to flight.

GATES OF SIRION, the rocky archway at the foot of the range of hills known as ANDRAM from which the River SIRION emerged from underground 'with great noise and smoke'.

GELION, river rising in two branches in East BELERIAND: Little Gelion in HIMRING and Greater Gelion in MOUNT RERIR. Flowing southwards, it was fed by six rivers rising in ERED LUIN. Between the river's two northern arms was the ward of Maglor where, in one place, the hills ceased and provided a gateway through which Orcs from Morgoth's northern stronghold came into BELERIAND.

GINGLITH, river rising in West BELERIAND and flowing south to join the River NAROG above NARGOTHROND.

GONDOLIN, 'The Hidden Rock'; the greatest and fairest city of the Noldor in exile, protected by the Encircling Mountains and built by King Turgon on Amon Gwareth, a hill of stone in the grassy plain of Tumladen (the bed of a vanished lake from which the DRY RIVER had once flowed into the River SIRION). Inspired by the city of Tirion in the Blessed Realm, Gondolin had high white walls, shining fountains and golden and silver images of the Two Trees which – until their destruction by Morgoth and Ungoliant – had given light to Valinor.

Tuor came to Gondolin with a call from Ulmo for the people to abandon the city and go down the SIRION to the sea. King Turgon rejected the summons and Tuor remained in Gondolin where he married the king's daughter, Idril, who bore him a son, Eärendil. These three were among the few survivors when the whereabouts of the hidden city was betrayed to Morgoth by Maeglin and Gondolin fell to a great army of the Black Enemy's wolves, Orcs, Balrogs and dragons.

GREATER GELION, see GELION

HIMLAD, 'Cool Plain', south of the PASS OF AGLON, the territory of Celegorm and Curufin, sons of Fëanor.

HIMRING, 'Ever-cold'; the wide-shouldered hill west of Maglor's Gap where Fëanor's eldest son, Maedhros, built his chief citadel.

HITHLUM, 'Land of Mist', through which Fëanor and the Elves of the Noldor passed on their way to MITHRIM. Following Fëanor's death, the Elves of the Noldor met emissaries of Morgoth to parley for peace and for the surrender of the Silmarils. But the Elves were ambushed, and many were killed. Fëanor's eldest son, Maedhros, was taken hostage and held in Angband, after which his brothers fortified a great camp in this place. Here, too, came the Elves led by Fingolfin who had crossed to Middle-earth by the Grinding Ice and whose son, Fingon (aided by the King of the Eagles), rescued Maedhros and so healed the rift between the two houses. Later, Tuor was held captive here by Lorgan, Chief of Hithlum's Easterlings.

IANT IAUR, 'The Old Bridge' (also referred to as the Bridge of Esgalduin), crossing the River ESGALDUIN to the north of DORIATH.

ISLE OF BALAR, said to be a remnant of Tol Eressëa, the island on which Ulmo carried the Vanyar and Noldor and, later, many of the Teleri from BELERIAND to Aman in the west. Too much in love with the starlit sea, the Teleri

preferred not to complete the journey and the isle was halted, rooted to the ocean bed in the Bay of Eldamar (Elvenhome) by Ulmo's servant, Ossë. The Elves eventually relented, building great white ships in which they sailed to Aman under the guidance of Ossë, who gave them many strong-winged swans to pull their vessels. Elves from NARGOTHROND later explored Balar as a potential refuge if Morgoth's evil should overrun Beleriand; and it was from Balar's shores that messengers of Turgon, king of GONDOLIN, embarked on fruitless quests for Valinor to seek the pardon and help of the Powers against Morgoth. The Isle became the last sanctuary for those Elves fleeing the Havens after the devastation of the Fifth Battle.

IVRIN, the lake and waterfalls below the southern walls of ERED WETHRIN, the source of the River NAROG. It was

near these falls that Finrod Felagund and Beren killed a company of Orcs and, by Finrod's craft, assumed the likenesses of Orcs to aid their journey towards Morgoth's stronghold at Angband. After Túrin had accidentally killed his friend Beleg Strongbow, a draught of the Ivrin's crystal water healed his grieving madness.

LADROS, lands to the north-east of DORTHONION (TAUR-NU-FUIN) which the Noldorin kings granted to the Men of the House of Bëor.

LAKE HELEVORN, 'Black Glass'; a lake – deep and dark – below MOUNT RERIR in the north of THARGELION, on the shore of which dwelt Caranthir.

LAKE MITHRIM, a lake in HITHLUM beside which Fëanor's Noldor made their first encampment on their return to Middle-earth.

LAMMOTH, 'The Great Echo'; the land to the north of the FIRTH OF DRENGIST. Its name refers to the echoes of Morgoth's terrible cry when he became ensnared in the dark webs of Ungoliant the spider.

LEGOLIN, the third tributary of the River GELION, rising in ERED LUIN.

LINAEWEN, 'Lake of Birds'; the great mere of NEVRAST inhabited by a multitude of those birds that love 'tall reeds and shallow pools'.

LITTLE GELION, see GELION

LOTHLANN, 'The wide and empty'; the great plain to the north of the MARCH OF MAEDHROS.

MALDUIN, 'Yellow River', rising in ERED WETHRIN and joining the River TEIGLIN to the west of the Forest of BRETHIL.

MARCH OF MAEDHROS (also called 'The Eastern March'), open lands to the north of the headwaters of the River GELION, held by Maedhros, son of Fëanor, and his brothers in readiness against an attack upon East BELERIAND.

MARSHES OF NEVRAST, marshlands surrounding LINAEWEN, the 'Lake of Birds'.

MENEGROTH, 'The Thousand Caves'; the hidden halls of Thingol and Melian, built with the aid of Dwarves on the east bank of the River ESGALDUIN; the fairest dwelling of any king in Middle-earth, filled with carvings and tapestries and lit with lanterns of gold. Here, in a smithy deep below the halls, Thingol was slain by Dwarves of NOGROD lusting for the Silmaril won from Morgoth by Beren and Lúthien. The jewel was recovered and Thingol's assassins were caught and killed, but an army of the Dwarves' kindred attacked and plundered the city in vengeance. Dior, son of Beren, having inherited both the Silmaril and Thingol's throne, re-established Menegroth only to be slain in his turn when the sons of Fëanor assailed DORIATH, claiming the jewel for themselves. Dior's daughter, Elwing, eluded the Noldor and escaped with the Silmaril to the MOUTHS OF SIRION.

MINDEB, a tributary of the River SIRION, rising under the southern walls of CRISSAEGRIM and flowing south between DIMBAR and the Forest of NELDORETH.

MITHRIM, the region chosen by Fëanor for his encampment on the return of the Noldor from the Blessed Realm. Before the camp was completed or put in defence, Orcs attacked by night and the Second Battle of the Wars of BELERIAND was fought: a conflict named Dagor-nuin-Giliath, 'The Battle-under-Stars'. This territory was later inhabited by Fingolfin's folk, who dwelt by the shores of LAKE MITHRIM.

MOUNTAINS OF MITHRIM, a range of peaks separating MITHRIM from DOR-LÓMIN.

MOUNT DOLMED, 'Wet Head'; mountain beneath the shoulder of which ran the DWARF ROAD.

MOUNT RERIR, mountain standing to the north of LAKE HELEVORN, from where the Greater GELION flowed south-west. The lands in the region were held by Caranthir, Fëanor's son.

MOUNT TARAS, mountain on the westernmost promontory of NEVRAST, beneath which Turgon dwelt at VINYAMAR until his departure to GONDOLIN.

MOUTHS OF SIRION, outlets of the River SIRION, beside which, for a time, dwelt many of the Teleri who did not sail west to Aman, under the kingship of Thingol's brother, Olwë. Instructed by Ossë, they came to love the sea and

its music, which inspired their exquisite singing. On these shores, Eärendil built his ship Vingilot, 'Foam-flower', in which he sailed to the Blessed Realm.

NAN DUNGORTHEB, 'The Valley of Dreadful Death' (between ERED GORGOROTH and DORIATH); so named because of the horror bred there by the spider, Ungoliant.

NAN ELMOTH, forest to the east of the River CELON, where Thingol (then called Elwë) was enchanted by the singing of Melian and was lost to the rest of his Elven company, who sailed into the west without him. Thingol and Melian married and ruled in splendour in the 'hidden halls' of MENEGROTH. Later, the smith Eöl (the Dark Elf) made his home here and ensnared Aredhel, the White Lady of GONDOLIN, whom he wed and who bore him a son, Maeglin.

NAN-TATHREN, 'Willow Vale' or 'Land of the Willows' on the southern course of the River SIRION, where it was joined by the River NAROG. Tuor, Idril and Eärendil rested here following their flight from the destruction of GONDOLIN.

NARGOTHROND, the great underground fortress on the River NAROG, situated in the caverns of the gorge under the wooded highlands called the High Faroth or TAUR-EN-FAROTH. It was inspired by Thingol's carved halls at MENEGROTH and built by Finrod assisted by the Dwarves of ERED LUIN, who gave him the name Felagund, 'cave-hewer'. From here, Finrod later accompanied Beren on

his quest to seize one of the Silmarils from the iron crown of Morgoth. Lúthien was held captive here until – aided by the hound, Huan – she escaped and went in search of Beren. The city was eventually destroyed by Glaurung, the Father of Dragons, and a great host of Orcs.

NAROG, river rising at IVRIN, under the southern walls of ERED WETHRIN, and flowing past Finrod's halls at NARGOTHROND to join the River SIRION in NAN-TATHREN.

NELDORETH, a mighty forest of beech trees forming the northern part of DORIATH, this was the birthplace of Lúthien, daughter of Thingol and Melian. In a song sung to Merry and Pippin in Fangorn, Treebeard remembers visiting the forest, 'To the beeches of Neldoreth I came in the Autumn. Ah! the gold and the red and the sighing of leaves in the Autumn in Taur-na-neldor!'

NENNING, river rising in the hills of West BELERIAND and flowing down to the Great Sea at the Haven of EGLAREST.

NEVRAST, 'Hither Shore'; the region between ERED LÓMIN and the western sea, for many years held by Turgon, son of Fingolfin.

NIMBRETHIL, birchwoods in ARVERNIEN to the east of CAPE BALAR.

NIVRIM, 'The West March', woodland west of the River SIRION which contained many great oak trees.

NOGROD, or 'Hollowbold' (hollow dwelling); one of the two great cities of the Dwarves (the other being BELEGOST) built in the eastern side of ERED LUIN. The Dwarvish name for the city was Tumunzahar.

OSSIRIAND, 'Land of Seven Rivers' (the GELION and its six tributaries), inhabited by the Green-elves, whose singing could be heard beyond the River Gelion. The Noldor, as a result, called the land 'Lindon', or 'The Land of Music', and the mountains of ERED LUIN they named ERED LINDON. Treebeard, in recollecting in song his years of wandering Middle-earth, told Merry and Pippin, 'I wandered in Summer in the elm-woods of Ossiriand. Ah! The light and the music in the Summer by the Seven Rivers of Ossir!'

PASS OF AGLON, 'The Narrow Pass' between HIMRING and DORTHONION which provided a gate to DORIATH and was fortified and held by Celegorm and Curufin.

PASS OF ANACH, leading out of TAUR-NU-FUIN between the walls of CRISSAEGRIM and the western peaks of ERED GORGOROTH.

RAMDAL, 'Wall's End', where the dividing wall of ANDRAM came to an end, west of AMON EREB.

RAVINES OF TEIGLIN, through which the River TEIGLIN flowed south of the Forest of BRETHIL. The woodland west of the River SIRION, between its confluence with the Teiglin and AELIN-UIAL, contained many great oak trees and was called NIVRIM, 'The West March'.

REALM OF NARGOTHROND, the Noldorin kingdom strad-
dling the river NAROG, ruled from NARGOTHROND by
Finrod.

REGION, dense forest lands in the southern part of
DORIATH.

RERIR, see MOUNT RERIR

RINGWIL, river which 'tumbled headlong' from the High
Faroth to join the River NAROG as it flowed past the
Elven city of NARGOTHROND.

RIVIL'S WELL, the source of the Rivil, a stream which fell
northwards to join the waters of the River SIRION in
the FEN OF SERECH. Here Beren slew the Orc captain
responsible for the death of his father, Barahir.

SARN ATHRAD, 'The Ford of Stones', where the DWARF
ROAD crossed the River GELION: the place where
Beren and Green-elves from OSSIRIAND ambushed the
Dwarves of NOGROD as they returned from their sack of
MENEGROTH. Beren took the recovered Silmaril back
with him to TOL GALEN, where the flame of the beauty
of Lúthien as she wore it made the isle like a vision of
Valinor.

SIRION, 'The Great River' of BELERIAND, rising at EITHEL
SIRION, running along the outer reaches of ARD-GALEN,
through the FEN OF SERECH and the pass between
ERED WETHRIN and DORTHONION, around the isle of
TOL SIRION, between BRETHIL and DIMBAR, through

DORIATH and the FENS OF SIRION, over the FALLS OF SIRION and through the willow-meads of NAN-TATHREN to the BAY OF BALAR.

TALATH DIRNEN, 'The Guarded Plain'; part of the REALM OF NARGOTHROND to the east of the River NAROG, laid waste by the dragon, Glaurung.

TARAS, see MOUNT TARAS

TARN AELUIN, a moorland lake by which Barahir and the Men of DORTHONION lived as outlaws until discovered and slain by the forces of Morgoth's lieutenant, Sauron.

TAUR-EN-FAROTH, wooded highlands (also known as the High Faroth) from where the River RINGWIL plunged into the River NAROG above the site of the Elven city, NARGOTHROND.

TAUR-IM-DUINATH, 'The Forest between Rivers', situated south of the ANDRAM between the Rivers SIRION and GELION; a 'wild land of tangled forest' untravelled by all except a few wandering Dark Elves.

TAUR-NU-FUIN, 'The Forest under Nightshade', once called DORTHONION, 'The Land of Pines'. Here, Túrin mistakenly slew his friend Beleg Strongbow who was attempting to rescue him from Morgoth's Orcs.

TEIGLIN, river rising in ERED WETHRIN, and flowing into the River SIRION in DORIATH. At Cabed-en-Aras, a deep gorge south of the CROSSINGS OF TEIGLIN, Túrin slew

Glaurung the dragon and Nienor, having learned that she was to bear the child of her brother, threw herself into the river. Later, Túrin returned to this place to kill himself. It was at this place of doom that Húrin, Túrin's father, having been released by Morgoth, was briefly reunited with his wife, Morwen.

THALOS, river flowing from ERED LUIN to the River GELION of which it was the second tributary. Near its springs, Finrod Felagund encountered Balan (later called Bëor) and the first Men to cross the Blue Mountains.

THARGELION, 'The Land beyond Gelion'; the region lying between the River GELION to the west and ERED LUIN to the east and between MOUNT RERIR in the north and the River ASCAR in the south. This was the territory of Fëanor's fourth son, Caranthir, who was later slain in the assault on DORIATH. In these lands (which the Grey-elves originally named Talath Rhúnen, 'The East Vale') the Noldor first met the Dwarves from the Blue Mountains. The Men known as the Haladin settled here after entering BELERIAND and encountering hostility from the Green-elves of OSSIRIAND.

TOL GALEN, 'The Green Isle', in the River ADURANT in OSSIRIAND where Beren and Lúthien dwelt on their return from the dead, and where the Silmaril cut from

Morgoth's crown was held for a time. The region came to be called Dor Firn-i-Guinar, 'Land of the Dead that Live'.

TOL SIRION, island in the River SIRION, running through the pass between ERED WETHRIN and DORTHONION, on which Finarfin's son, Finrod Felagund, built Minas Tirith, 'The Tower of Watch'. When the tower was captured by Sauron, it was known as Tol-in-Gaurhoth, 'Isle of Werewolves'. Beren and Finrod were imprisoned on this island by Sauron, and it was here that Finrod died saving Beren from a werewolf sent by Sauron to devour him. Huan the hound carried Lúthien to the tower and overcame Sauron himself in wolf's form, after which Lúthien took the mastery of the isle and released its captives.

TUMHALAD, a valley between the Rivers GINGLITH and NAROG where in battle with the forces of Morgoth 'all the pride and host of NARGOTHROND withered away', defeated by a great army of Orcs and the dragon, Glaurung.

VINYAMAR, 'New Dwelling'; the house in NEVRAST of Turgon, the second son of Fingolfin and founder of the Elven city of GONDOLIN. Many Elves dwelt in this region by the sea because the Vala Ulmo and his servant, Ossë, had once been frequent visitors to these shores. Here Tuor arrayed himself in armour left by Turgon and was sent by Ulmo to Gondolin to warn the king and his people to leave their city and go to the sea.

WEST BELERIAND, see BELERIAND

Where on Earth is Middle-earth? Clearly, there is a geography of the imagination that knows no borders. I have found all three Ages of Middle-earth in many places, from Torres del Paine in Chile to Switzerland's Gorges de l'Areuse, from the same Alps Tolkien hiked through in 1911 to the shores of British Columbia's Haida Gwaii… but one country perhaps contains more of Middle-earth, and especially Númenor and the Second Age, than most: New Zealand. Aotearoa has been an incredible source of inspiration. Places such as Three Sisters Beach, White Rock, Tarawera Falls and many more have immediately struck me, fired my imagination, and found their way into many drawings and paintings. These unexpected concordances of landscapes imaginary and real are enthralling.

For my map of Númenor, I pored over Christopher Tolkien's crisp and detailed drawing of the island kingdom, and read and reread 'A Description of the Island of Númenor' in Unfinished Tales, *always wishing that the author had seen fit to include more names and places. The star-shape of Númenor allowed a grand latitude for illustrations to surround the island, albeit in constraining formats. The bottom image, Cape Forostar, is just over two hours south-east from Wellington.*

John Howe

THE LAND OF THE STAR

About the Map of Númenor

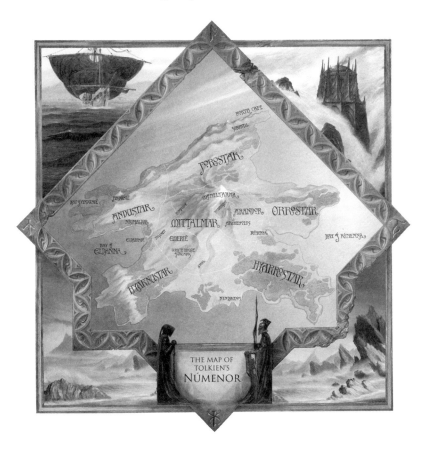

THE MAP OF
TOLKIEN'S
NÚMENOR

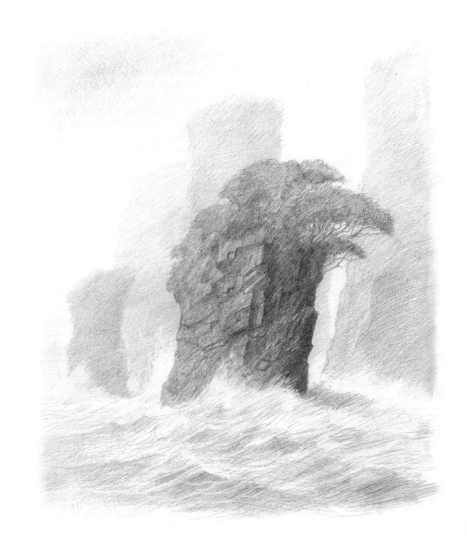

A lthough long lost beneath the waters of the Sundering
Sea, the Island of Númenor lived on as a deep yearn-
ing within the hearts of those who survived its downfall.
And, whilst more than three thousand years separated the
fall of Númenor and the struggles of the War of the Ring,
those two events and the fate of those involved were linked
by an inextricable bond.

There are, in *The Lord of the Rings*, several tantalising
references to Númenor and its people; and the doomful
history of this enigmatic island set in the seas to the west of
Middle-earth held a great fascination for Tolkien. Númenor
was a potential subject for various incomplete literary pro-
jects such as 'The Lost Road' and 'The Notion Club Papers',
posthumously published in volumes 5 and 9 of *The History
of Middle-earth*. Accounts of Númenórean history can also
be found in 'Akallabêth (the Downfall of Númenor)' in *The
Silmarillion* and in those chapters relating to the Second
Age in *Unfinished Tales*, which also contains the only rep-
resentation of Númenor, mapped by Christopher Tolkien
and now the inspiration for this new visualisation by John
Howe. More of Tolkien's texts about Númenor were later

included in *The Nature of Middle-earth* (2021); and *The Fall of Númenor* (2022) collected into one volume all these and many other writings about the island, its people and events during the Second Age of Middle-earth.

It was at the beginning of the Second Age that the land of Númenor was brought into being.

Following the overthrow of Morgoth and his expulsion beyond the World, the Valar, the Lords of the West, held a council and called upon the Eldar (the Firstborn race of Middle-earth, the Elves) to return into the west and dwell on Eressëa, the Lonely Isle that, of all lands, lay closest to Valinor, the Blessed Realm.

The Valar also took thought for the needs of those of the second-born race of Men (known in the Elvish tongue of Sindarin as the Edain), who had fought against Morgoth in alliance with the Elves. For these Elf-friends, the Valar made a new land which was neither part of Middle-earth nor of the Blessed Realm, being sundered from each by a wide sea, though lying nearer to Valinor.

Raised from the depths of the sea by Ossë, servant of Ulmo, Lord of the Waters, the island resembled, in shape, a five-pointed star or pentangle. Established by Aulë, who among the Valar was a smith and a master of crafts, the island was made fair and rich by Yavanna, 'the giver of fruits'. When all had been made ready, the Star of Eärendil shone with a new brilliance in the West as a guide to those of the Edain who would embark from Middle-earth on the journey across the Great Water.

Then was a choice of destiny given to the brothers Elros

and Elrond who were of the Peredhil, the Half-elven, in whom was mingled the blood of Men and Elves. The choice either to remain with the Elvenkind and share in the Eldar's gift of immortality, or to choose the kinship of Men and accept the fate of mortality following a span of years many times greater than that of other Men of Middle-earth.

Elrond chose to remain among the Firstborn in Middle-earth where he would establish the haven called Imladris, or Rivendell, and, some two thousand years later, would participate in the Last Alliance of Men and Elves against the might of Sauron and, in the Third Age, the War of the Ring.

Elros, however, chose to be a mortal Man, and in the thirty-second year of the Second Age of Middle-earth set sail with the Edain, across seas that were calmed by the Valar, towards a land that shimmered upon the waters in a golden haze.

The Valar named it Andor, the Land of Gift, but the Edain called it Elenna, or Starwards, in commemoration of the guidance they had received from the Star of Eärendil. In the language of the Edain it was also called Anadûnê or, in the Elvish tongue Quenya, Númenórë or Númenor: names translated as Westernesse or Westland.

This was the beginning of the people known as the Dúnedain, the Edain of the West. Elros became their first king, taking the name Tar-Minyatur and establishing the great citadel of Armenelos from where he would rule for four hundred and ten years.

The name Dúnedain would still be used in the Third Age, long after the fall of Númenor, to speak of the Rangers of

whom Aragorn son of Arathorn was called the Chief of the Dúnedain in the North or *the* Dúnadan.

The Dúnedain named the regions around the five promontories of Númenor, calling them Forostar (Northlands), Andustar (Westlands), Hyarnustar (Southwestlands), Hyarrostar (Southeastlands), and Orrostar (Eastlands). The central portion was called Mittalmar (Inlands), a small portion of which was named Arandor, the Kingsland.

Blessed by the Valar and given the friendship of the Eldar, who came regularly by ship out of the West to share their wisdom and lore-craft and to teach the people the High Eldarin language, the Dúnedain prospered greatly. The Eldar also brought many rare gifts to Númenor, including Nimloth, a seedling from the White Tree that grew in Eressëa, which was planted in the courts of the king in Armenelos.

Out of awe and love for the Valar and in gratitude for the Land of Gift, the Dúnedain worshipped Eru Ilúvatar, The One, on the summit of the Hallowed Mountain called Meneltarma, or the Pillar of the Heavens.

The building of ships was one of the skills acquired by the Edain and, with their mastery of sea-craft, many of their race undertook long and, sometimes, perilous voyages such as are recorded in 'The Mariner's Wife', a fragment found in *Unfinished Tales*. This tells, in part, the history of Aldarion, son of Tar-Meneldur, the fifth king of Númenor, and of Aldarion's wife, Erendis, whose White House is shown on the map of Númenor.

Despite the Númenóreans' sea-craft, the Valar – attempting to prevent the Dúnedain from being tempted by a yearning

for the immortality enjoyed by those of the Blessed Realm – imposed a limitation on their voyaging by decreeing that they should not sail so far westward that they lost sight of the coast of Númenor. After two thousand years of accepting this ban, the Dúnedain began to question why, despite the many years of life which they enjoyed, they eventually had to endure the doom of death.

Unrest was also stirring in Middle-earth. Sauron had risen once more and, alarmed by the growing might of the Númenóreans, established a stronghold in Mordor with the building of the Barad-dûr, a task that would take six hundred years to complete. Disguised in the 'fair form' of Annatar ('Lord of Gifts'), he went to Celebrimbor and the Elven-smiths of Eregion purporting to be an emissary from the Valar. Under Sauron's deceitful tutelage, the Elves' skill was greatly enhanced and with his help they forged the Rings of Power. It was Sauron's plan to use these rings to dominate the Elves of Middle-earth, so in the fires of Mount Doom he forged for himself the One Ring to rule the others.

Unbeknownst to Sauron, Celebrimbor had alone forged the Three Rings and as soon as Sauron put on his own Ring the Elves became aware of the deceit that had been worked upon them and took off their own. Furious at this thwarting of his plans, Sauron assembled and trained an army and, ninety years later, he began to wage war on the Elves. During this conflict, Tar-Minastir, the eleventh king of Númenor, sent a huge navy, by whose aid Sauron was, for a time, defeated. It was during the reign of the thirteenth king of Númenor, Tar-Atanamir, that the Valar, hearing of

the growing disquiet about the ban on sailing too far into the West, sent Messengers from among the Eldar to warn the Dúnedain against rebellion. But by the accession of the next monarch, Tar-Ancalimon, the people of Númenor were divided into two factions: the King's Men, who were estranged from the Firstborn and the Valar, and who were in the majority; and the Elendili, or Elf-friends, who accepted the ruling of the Lords of the West and remained friends with the Eldar.

While some among the wise of the Dúnedain sought for a way of restoring life to the dead, the kings built themselves tombs of ever greater splendour for the preservation of their earthly remains.

The Dúnedain also began to turn their frustrated ambitions towards dominion in Middle-earth, where Sauron's shadow had once more stretched forth with the appearance of the Nazgûl, the slaves of the Nine Rings, among whom it was said were numbered three great lords of the Númenórean race.

In the year 3255 of the Second Age, Ar-Pharazôn became the twenty-fifth monarch to take up the Sceptre of the Sea Kings. Learning that Sauron's strength was growing in Middle-earth, that he had taken the title King of Men and declared his intention of destroying Númenor, Ar-Pharazôn planned a mighty assault upon the East.

Confronted with the might of Númenor, Sauron made no offer of battle, rather one of fealty to Ar-Pharazôn, even permitting himself to be taken to Númenor as hostage. Within three years, however, by flattery and subtle deceit,

Sauron became Ar-Pharazôn's closest counsellor and began to turn the king towards the worship of Melkor, the Lord of the Dark. Alone among the king's counsellors to remain faithful to Ilúvatar was Amandil who, with his son Elendil and grandsons Isildur and Anárion, left the royal city of Armenelos for the seaport of Rómenna.

Sauron continued his corruption of Ar-Pharazôn by urging the king to cut down the White Tree, Nimloth the Fair. Before this deed was done, Elendil's son, Isildur, went in disguise to the courts of the king, passed through the guards and seized a fruit from the tree. But the guard was aroused and Isildur, forced to fight, sustained many wounds in making his escape. Then Ar-Pharazôn gave in to Sauron's wishes and the White Tree was felled. But the fruit stolen by Isildur was planted in secret and, tended by Amandil, took root and grew.

Abandoning all further allegiance to Ilúvatar, Ar-Pharazôn erected, at Sauron's bidding, a great temple. Standing five hundred feet high and with walls fifty feet thick at their base, this temple had a silver dome that at first shone in the sun but was soon blackened by the smoke which issued through an opening, and which arose from the sacrificial fire that Sauron kindled upon the altar with the wood of Nimloth.

Númenor was filled with unrest and senseless killing and, with Sauron's hand guiding the king, Ar-Pharazôn grew to be a tyrant, making war on the people of Middle-earth whom he enslaved or had sacrificed upon the altars of Melkor.

Then, when the King's life was moving towards its end, Sauron completed his ambitious scheme by convincing Ar-Pharazôn that he was now worthy of the gift of life

unending and that, if it were to be denied him by the Valar, he should demand it by force of arms.

As the king plotted war against the Valar, Amandil took ship into the West, hoping to seek the counsel of the Valar and avert disaster for his people. Although the end of this voyage was never to be known, Amandil's son, Elendil, and his sons Isildur and Anárion, gathered the Faithful in secret and outfitted ships in which to flee from Númenor, taking with them scrolls of lore, heirlooms and the young tree grown from the fruit of Nimloth the Fair.

The clouds of war grew darker and Ar-Pharazôn finally went aboard his great ship, Alcarondas, Castle of the Sea, and set sail leading a mighty fleet into the West, breaking the ban of the Valar, sailing past the isle of Eressëa, home of the Eldar, and on to Aman, the Blessed Realm.

Ilúvatar made his response by bringing upheaval into the world: the hills fell upon Ar-Pharazôn and his men, a chasm opened in the sea between Valinor and Númenor, swallowing the King's fleet, and destruction came to the Land of Gift. With wind and earthquake and an eruption of fire from the summit of Meneltarma, Númenor with all its people went down into the sea and its wealth and wisdom were lost for ever.

At this time, the form of the world was changed: new lands and new seas were made and Valinor and the haven of the Eldar, Eressëa, were placed beyond the reach of Men in the realm of hidden things. Thereafter, the way to the Blessed Realm of the West became known as the Lost Road.

The Faithful of Númenor, led by Elendil, Isildur and

Anárion, escaped destruction when the great upheaval of the waters that brought doom to their land cast their nine ships upon the shores of Middle-earth. Here, they had yet a role to play in the struggles against Sauron in the closing century of the Second Age.

Sauron was seated in the Temple at Armenelos when ruin came upon Númenor, and was hurled into the abyss. Being of the Maiar, he was not destroyed, though he could never again assume a shape that was pleasing in the eyes of Men. As spirit he rose from the depths, passed over the sea as wind and shadow and returned to the Dark Tower, in the land of Mordor. There, reunited with the One Ring, he became the all-seeing Eye of Sauron the Terrible.

With the passing of Númenor, the land of many names from then on became known as Mar-nu-Falmar, the Land Under the Waves, and as Akallabêth the Downfallen or, as it is in the tongue of the High-elves, Atalantë.

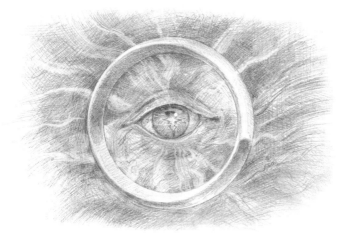

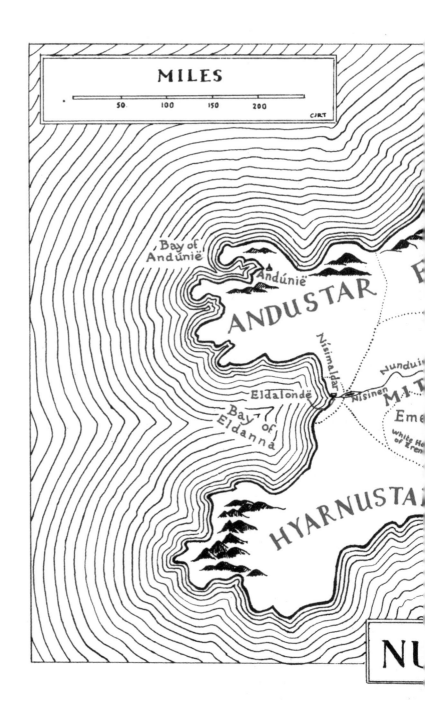

MILES

50 100 150 200

C.JRT

Bay of
Andúnië

Andúnië

ANDUSTAR

Nísimaldar

Nundui

Eldalondë

Nísinen

MIT

Emere

Bay of
Eldanna

White He
of Ërem

HYARNUSTAR

NU

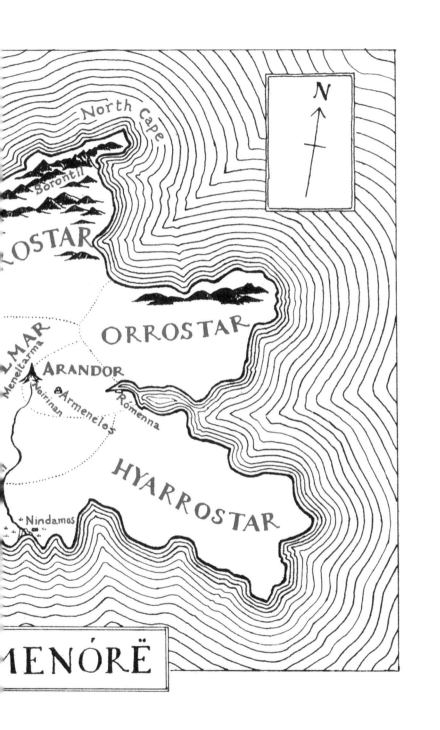

N

North Cape

Sorontil

�‌OSTAR

ORROSTAR

⅃MAR

Meneltarma

ARANDOR

Noirinan

Armenelos

Rómenna

HYARROSTAR

Nindamos

ᴍENÓRË

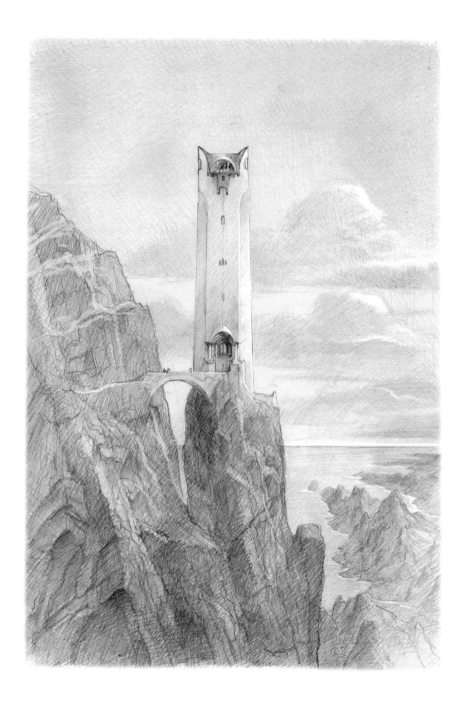

PLACES ON THE MAP
OF NÚMENOR

ANDÚNIË (Sunset), the great haven in the BAY OF ANDÚNIË, with a town standing at the edge of the shore and with many other dwellings scattered up the steeply-rising inland slopes. The Lord of Andúnië, who stood highest in honour after the house of the kings, had great love for the Eldar and, even as the Shadow grew in Númenor, retained the reverence for the Valar. It was to this haven that the ships of the Eldar of Eressëa would come bearing gifts including flowers and herbs and a seedling of Celeborn, the White Tree that grew in the midst of Eressëa. Here, during the reign of Tar-Meneldur, Aldarion the King's Heir brought Erendis, by ship on a coastal voyage from RÓMENNA, hoping that it would allay her dislike and distrust of the sea. Later he returned with her as his bride and future queen for a feast that was blessed by a visitation from the Eldar. Such visits from the Firstborn continued until the days of Ar-Gimilzôr, the twenty-third king of Númenor, during whose reign

the Eldar were referred to as the Spies of the Valar and came no more out of the West.

ANDUSTAR (Westlands), a region of dramatic contrasts: from the rocky northern and north-western coastline with its three bays, the northernmost of which was the BAY OF ANDÚNIË which embraced the haven of ANDÚNIË, to the fertile lands in the south with their woods of birch, beech, oak and elm and those lands known as ELDALONDË, NÍSIMALDAR and the country around the BAY OF ELDANNA.

ARANDOR, though only a small portion of the MITTALMAR (Inlands) separated and designated the Kingsland, this was the most heavily populated region of Númenor. Here was the haven of RÓMENNA, the Hallowed Mountain, MENELTARMA, and the great city of ARMENELOS.

ARMENELOS, the City of the Kings, the dwelling of the rulers of Númenor in ARANDOR to the east of MENELTARMA. The tower and citadel were raised by Elros, son of Eärendil, who was appointed by the Valar as the first King of the Dúnedain. The city became one of great wealth and splendour and it was here that Ar-Pharazôn, the twenty-fifth king of Númenor, brought Sauron as a hostage from Middle-earth. But later, he became close to the king, turning him towards the worship of Melkor, Lord of Darkness, and the building of a great temple, bringing about an end to the observances on MENELTARMA. Sauron then caused the White Tree to be cut down and burnt upon the temple altar and,

eventually, incited Ar-Pharazôn to take arms against the Valar, sailing with a mighty force to the Blessed Realm: which act brought about the destruction of Númenor.

BAY OF ANDÚNIË, the largest and northernmost of the three bays on the coast of the ANDUSTAR, sheltering the haven of ANDÚNIË.

BAY OF ELDANNA, sheltered by the promontories of the ANDUSTAR and the HYARNUSTAR, this great bay received its name because it faced towards Tol Eressëa, easternmost of the Undying Lands from where, in the early days of Númenor's history, the Eldar came in their swift, white ships bringing gifts to enrich the lives of the Númenóreans. At the centre of this bay was the verdant haven known as ELDALONDË the Green.

ELDALONDË, named Haven of the Eldar (because it was said to have been as fair as any haven in Eressëa), this region was also known as Eldalondë the Green, since, being open to the western sea and sheltered from the north, it enjoyed a warm, wet climate in which many sweet-smelling trees thrived on the seaward slopes of the bay and far inland, so that this area was known as NÍSIMALDAR, the Fragrant Trees.

EMERIË, a region of the MITTALMAR comprising rolling grasslands used for the pasturing of sheep. It was here that Erendis brought Aldarion, the King's Heir, hoping to awaken in him a love of the lands of Númenor rather than the sea. Here was built the WHITE HOUSE OF ERENDIS.

FOROSTAR (Northlands), the least fertile region of Númenor comprised heather-covered moors and a few wooded slopes of fir and larch. This stony region included the rocky heights of the NORTH CAPE and the towering mass of SORONTIL, rising sheer from the sea and being an abode of many eagles.

HYARNUSTAR (Southwestlands), a diverse region with towering cliff-faces found along the western and southern coastline; while the fertile lands to the east sustained great vineyards. Between this region and that of the HYARROSTAR, the river SIRIL ran its course.

HYARROSTAR (Southeastlands), densely forested with, among other trees, the yellow-flowered *laurinquë*, erroneously supposed to have been descended from Laurelin, the younger of the Two Trees of Valinor, sometimes called the Tree of the Sun. From the reign of Tar-Aldarion, Númenor's sixth ruler, this became a region of many plantations, growing trees for ship-building enterprises favoured by this monarch known as the Mariner King.

MENELTARMA, a tall mountain (some 3,000 feet in height) situated towards the centre of the MITTALMAR, and dedicated to the worship of Eru Ilúvatar. The name, in translation, means the Pillar of the Heavens, but it was also referred to as the Holy or Hallowed Mountain. The base of the mountain comprised five long, low ridges radiating out towards the promontories known as the Tarmasundar, the Roots of the Pillar. Between the southeastern and southwestern ridges lay the shallow valley

known as NOIRINAN. The gentle, grassy slopes of the mountain grew increasingly steeper until, near the summit, the rock could not be scaled.

A road had been built beginning on the south-western ridge of Tarmasundar and spiralling up to the top and the Hallow, which, though unmarked by temple or altar, was a sacred place. There, neither tool nor weapon could be carried and none other than the king might speak and then on only three occasions during the year when the ruler offered prayers to Eru Ilúvatar. At the *Erukyermë*, during the first days of spring, the king would petition for Eru's aid in the coming year; at the *Erulaitalë*, in midsummer, prayers of praise were offered; while *Eruhantalë*, at the end of autumn, was a time of thanksgiving. The Hallow took the form of a natural arena, big enough to accommodate the vast number of people who would follow the king on these occasions, climbing the mountain road, dressed in white, wearing garlands and in silence.

The people were permitted to climb to the top at any time in the year, but the silence of the place was said to have been awesome. The only birds that were ever seen there were three eagles, known as the Witnesses of Manwë, who appeared whenever anyone approached the summit, and maintained a watch from three rocks on the western edge. On the occasions of the Three Prayers, however, they remained aloft, hovering on outspread wings above the Holy Mountain.

It is said that, when the air was clear and the sun was in the east, the keenest-eyed among the Númenóreans

could, from the top, glimpse the harbour and tower of Avallónë, the haven of Eldar, far off in the West. Aldarion and Erendis saw this sight and, that day, plighted their troth on the steep path down from the summit.

MITTALMAR (Inlands), higher than the surrounding regions of Númenor, this was a region of pasture and low downlands with little forestry. Near the centre stood the sacred mountain MENELTARMA, and, between its roots, NOIRINAN, the Valley of the Tombs.

NINDAMOS, chief village settled by the fishermen living and working on the white beaches and grey shingles that comprised the southern coast of the HYARNUSTAR around the mouths of the SIRIL.

NÍSIMALDAR, rich groves of woodlands surrounding the Haven of ELDALONDË. Many of the trees which flourished there had been brought to Númenor by the Eldar, among them *oiolairë* (Ever-summer), *lairelossë* (Summer-snow-white) and *yavannamírë* (Jewel of Yavanna), famed for its scarlet, globed fruits and which gave off such a sweet fragrance as to earn the area the name, in translation, the Fragrant Trees. Although these and other trees brought from Eressëa also grew, with less abundance, in other parts of Númenor, there was one tree that was found only in Nísimaldar: the mighty, golden-flowered *mallorn* tree. Gil-galad entrusted the fruit of the *mallorn* (a nut encased in a silver shale) to Galadriel and, under her power, the tree grew and flourished in the Middle-earth realm of Lothlórien, so giving it its name, The Golden Wood.

156

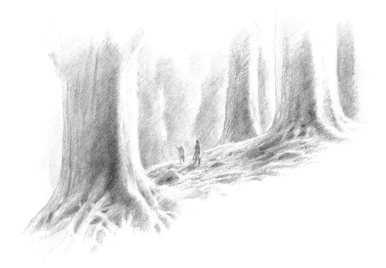

NÍSINEN, a lake in the seaward-course of the river NUNDUINË, its name came from the fact that many fragrant flowers and shrubs grew about its shores.

NOIRINAN (The Valley of the Tombs), situated between the southeastern and southwestern ridges of the Tarmasundar at the base of MENELTARMA. At the head of the valley, carved into the mountainside, were the sepulchres where the kings and queens of Númenor were enshrined in great splendour. As the Númenóreans became increasingly fearful of death and sought more urgently after the secret of eternal life, so dark and silent tombs proliferated throughout the land.

NORTH CAPE, the rocky highland area of the FOROSTAR, of which the highest place was SORONTIL. It was in this region, inhabited by many eagles, that Númenor's fifth

king, Tar-Meneldur Elentirmo, built a tall tower from which to study the heavens.

NUNDUINË, river flowing through the MITTALMAR (where, at the western border, it formed the lake NÍSINEN), through NÍSIMALDAR and out into the sea at ELDALONDË.

ORROSTAR (Eastlands), whilst a cooler region, these lands were protected from the cold north-easterly winds by a range of hills rising towards the end of the promontory, so that considerable quantities of grain was grown inland, particularly near to the borders of ARANDOR.

RÓMENNA, the great port to the east of ARMENELOS, serving ARANDOR and the City of the Kings. Here Tar-Meneldur's son, Aldarion, the Great Captain, built the ship *Hirilondë*, (Haven-finder), which men called *Turuphanto* (the Wooden Whale). Later, when Tar-Aldarion reigned as king, his wife Erendis perished in the waters of the Haven. In the bay of Rómenna lay the isle of Tol Uinen, where Aldarion moored his ship, *Eämbar*, that was also the house of the Guild of Venturers, and where, later, he would erect Calmindon, the Light-tower. It was here, following the rise of Sauron, that Amandil, former counsellor to King

Ar-Pharazôn, dwelt with his son Elendil and grandsons, Isildur and Anárion and, later, set sail for the West to seek the wisdom of the Valar concerning Sauron: a voyage from which he never returned. At the fall of Númenor, Elendil, his sons and those faithful to Ilúvatar fled from here by ship, carrying with them a sapling grown from a fruit of the White Tree, which Isildur, at great risk, had succeeded in stealing shortly before the felling of the tree.

SIRIL, Númenor's chief river which had its springs in the valley of NOIRINAN beneath MENELTARMA and ran southward, through the MITTALMAR, in a slow, meandering course, until, on reaching a wide, reedy marshland, it flowed out through many mouths into the southern sea.

SORONTIL (Eagle-horn), the great height on the NORTH CAPE of the FOROSTAR, which rose, sheer from the sea, as a towering cliff-face.

WHITE HOUSE OF ERENDIS built by Tar-Meneldur, the fifth king of Númenor, as a gift to Erendis on her betrothal to his son, Aldarion. Here, in her husband's absence at sea, Erendis, the White Lady, raised her daughter Ancalimë until the child was recalled to ARMENELOS where, in time, she became the first Ruling Queen of Númenor.

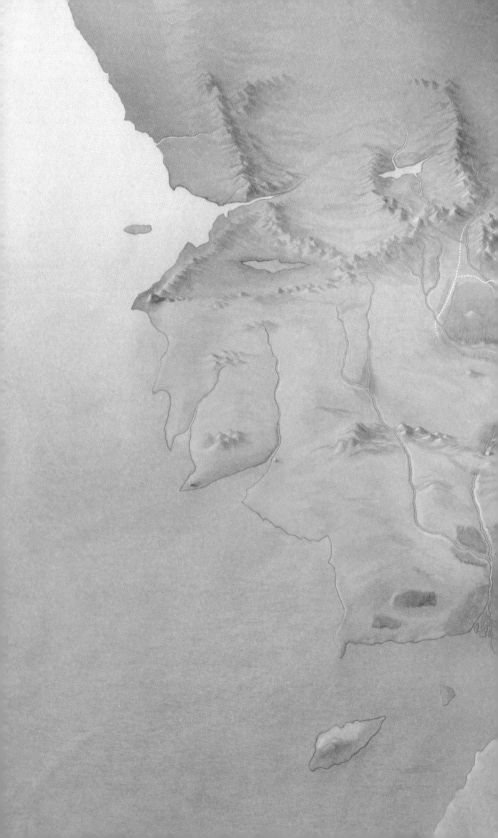